Dolls for the Princesses

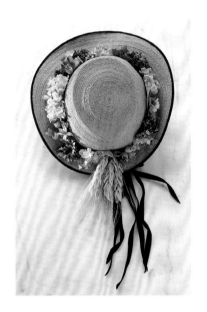

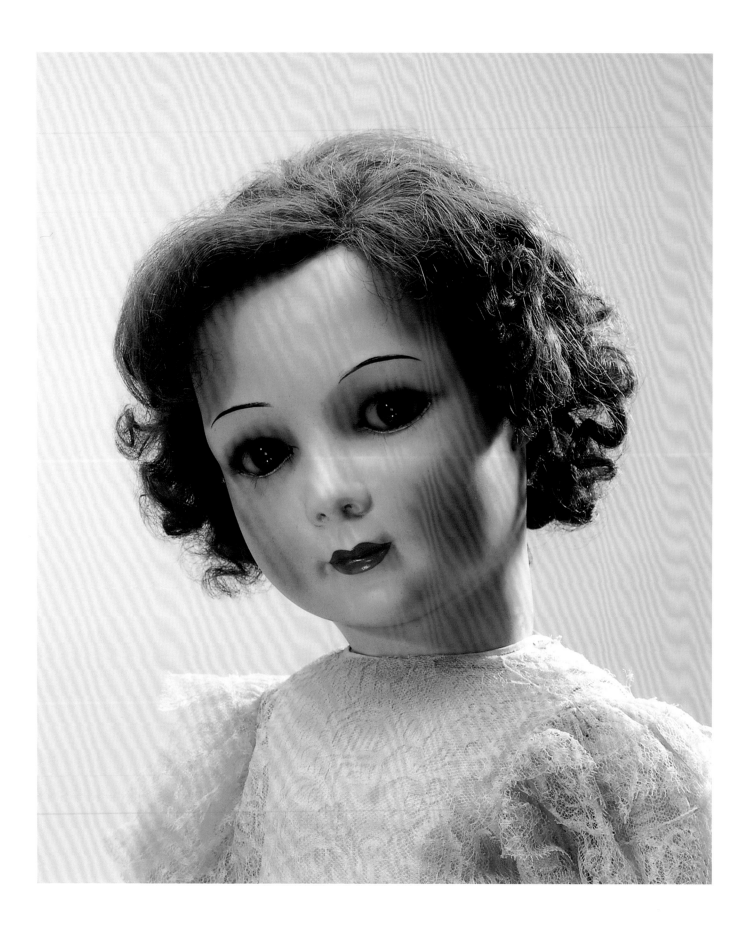

Dolls for the Princesses

THE STORY OF FRANCE AND MARIANNE

FAITH EATON

With a Foreword by Suzy Menkes

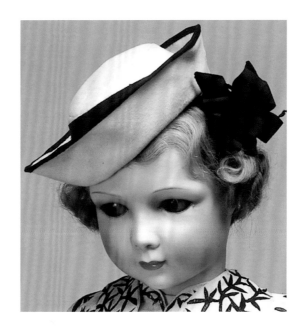

The Royal Collection

CONTENTS

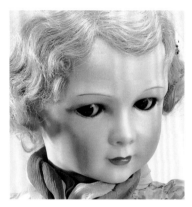 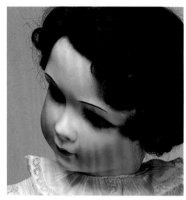

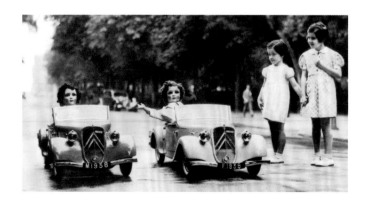

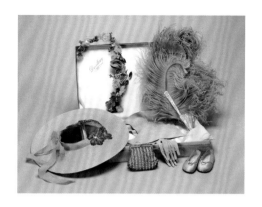

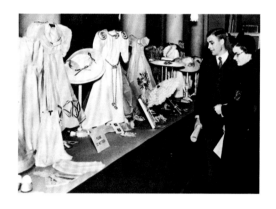

This book has been published with
support from De La Rue plc

DeLaRue

FOREWORD

When Queen Elizabeth opened her lacy parasol on the Île Enchantée, her hat wafting with feathers and her white skirts skimming the grass, she was, in her own person, paying a compliment to her Gallic hosts. The visit to Paris in 1938 of King George VI and his consort signalled an *entente cordiale* on the eve of war and a re-affirmation of the British monarchy. Queen Elizabeth, the future Queen Mother, expressed that majesty and her own affinity with French culture in the neo-Victorian outfits that couturier Norman Hartnell created for the State Visit.

The two extraordinary dolls presented as gifts for Princess Elizabeth and Princess Margaret Rose were also symbolic. Far more than royal playthings, they were intended as a testimony to French *savoir-faire*. France and Marianne – named after the country itself and the portrait bust that stood in each French town hall – had a 360-piece trousseau made with exquisite craftsmanship and entirely by hand in the great national tradition of haute couture.

Gauzy evening gowns, fur tippets, girlish dresses and sporty seaside outfits were a mirror image of current style, where a salty breath of fresh air mingled with salon elegance. The accoutrements of the grand life of an aristocratic young woman in the 1930s might have included life-size versions of the dolls' fur coats, hand-stitched negligées and a dress with wheatsheaf embroidery to match the embellishment on the straw hat.

The clothes also expressed a stratified social etiquette in which wardrobes were coded for the daily life of a lady. The complex bustles, underpinnings and hats of Edwardian grandeur had been simplified after Coco Chanel's fashion revolution in the 1920s and the slinky, bias-cut dresses of Madeleine Vionnet in the 1930s. Yet France and Marianne were still expected to wear a *café au lait* pleated satin morning dress, a satin matinée coat or a pink chiffon garden-party frock – and oiled silk raincoats for driving their miniature Citroën cars down the Champs Elysées.

The names of the couturiers are redolent of the fashion houses of that era. They included Lanvin, Rochas, Vionnet and Worth, as well as Cartier for the Art Deco-style jewellery, Vuitton for the splendid travel trunks and Coty or Lancôme for the bottles of fragrance.

These wardrobes are a time capsule of French fashion in 1938, where a century and a half of tradition was on the cusp of change. The arts of fine living had seeded in France when the 1789 revolution opened up to a wider public what had once been the preserve of a privileged few. The industrial revolution of the nineteenth century and the arrival of the department store – celebrated in Émile Zola's novel *Au Bonheur des Femmes* – served only to enhance the value that sophisticated women placed in Parisian skills: the sensual satin lingerie, lush kid gloves, parasols with jewelled handles, hand-painted fans and bead-encrusted bags.

Long after the Belle Époque, Marcel Proust's descriptions of Odette de Crécy in her silken tea gowns in a salon perfumed with lilies remained as much a benchmark of French style as the tinkle of Sèvres porcelain tea-cups. Even the Great War did not break the fashion thread, as Gallic style followed the sinuous path of Art Nouveau and the geometric modernism of Art Deco.

So by 1938, the couture houses who dressed the dolls and proudly sewed in their labels – and the dolls' royal recipients – could not have imagined that France's charming gift would become an instant period piece.

Yet the outbreak of the 1939–45 war, the subsequent arrival of factory-made ready-to-wear clothes and, above all, the inevitable changes to hierarchical society and its complex mores, have turned brunette Marianne and blonde France into a historical monument. Today, the glass vitrines on their display cases act as aspic to a bygone era.

SUZY MENKES
PARIS

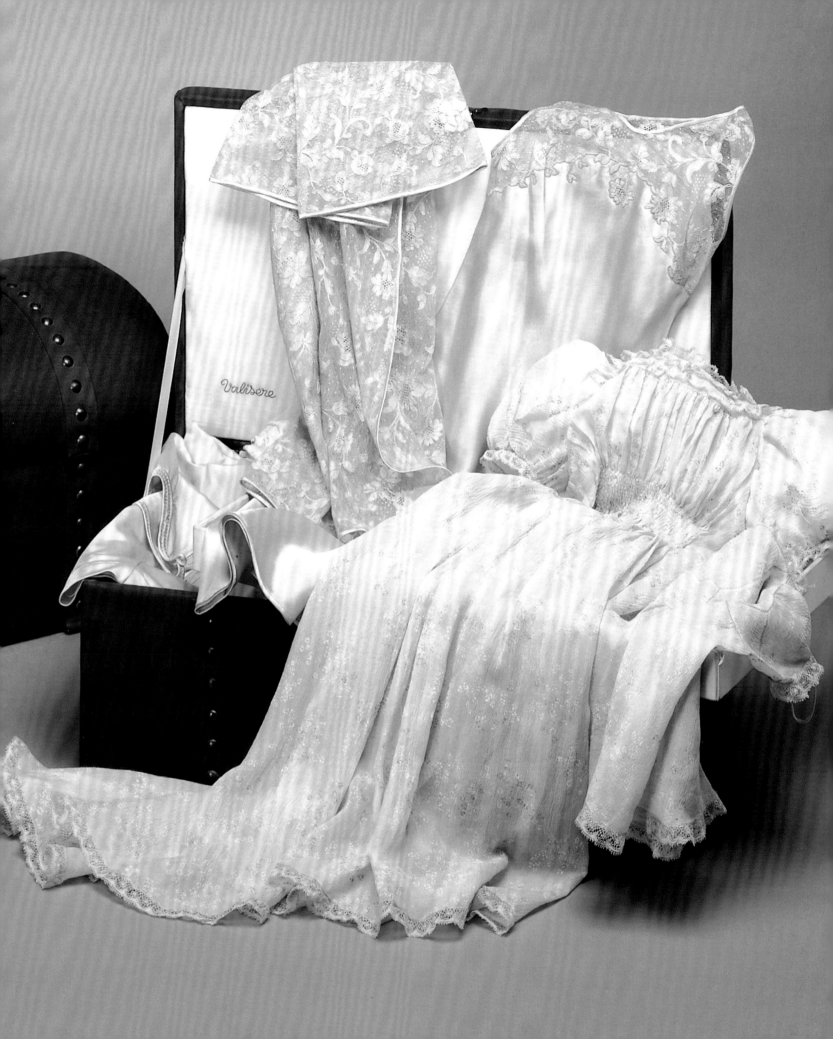

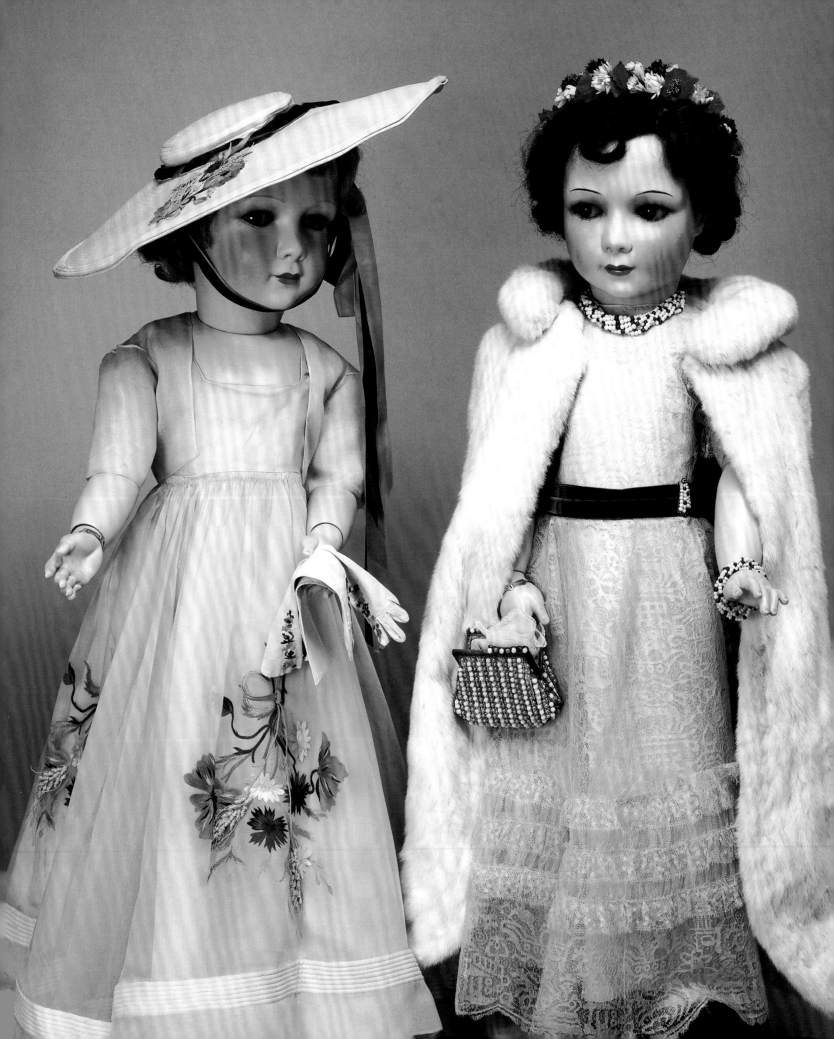

PREFACE

The letter that arrived one morning in the spring of 1992, inviting me to Windsor Castle to offer some advice on the display of dolls, was, of course, as intriguing as it was unexpected.

At that time the case near Queen Mary's Dolls' House contained a colourful selection of dolls dressed in historic or national costumes, gifts presented to Her Majesty The Queen over a period of years. There were two notable exceptions, a pair of bisque-headed dolls that had been placed at the back of the display. They had intrigued me since I had first seen them there, for although they were incognito amongst their companions, the quality of both the dolls and their clothes – one wore an ocelot coat over a day dress and the other an ermine cape over an evening dress – made them outstanding. To a collector with some knowledge of the history of dolls, they were irresistibly attractive, which might have been expected since they were, in fact, France and Marianne, the once famous gifts of the French children to the young Princesses Elizabeth and Margaret Rose, presented in 1938.

Preparing a report meant an opportunity to identify and improve the display of these two important dolls. My main suggestion was to remove all the other exhibits and use the case to show France and Marianne with a wide selection of their trousseaux and other possessions that were currently in store.

The second letter from the Royal Collection, informing me that it had been decided to use the refurbished case in this way, contained an even more fascinating request – one that would mean a prolonged involvement for me in both the display and conservation of these unique dolls and their trousseaux.

It was hardly surprising that examination would show that the delicate items of clothing, having been in store and unseen for many years, would need careful conservation before they could be displayed with the dolls. Both France and Marianne themselves also needed some measure of restoration.

Being a researcher as well as a conservator, I was concerned to try to discover

OPPOSITE: The dolls France and Marianne, created as the French children's gift to the English Princesses in 1938, had a unique influence on the worlds of fashion, diplomacy and charity fund-raising.

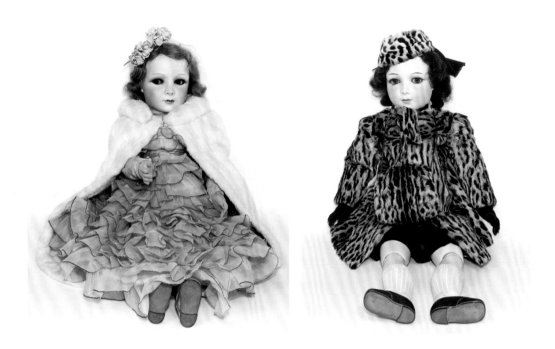

In 1955 the corridor case, near Queen Mary's Dolls' House, held fifty-six dolls, gifts made for members of the Royal Family. Though they were sitting at the back of the display incognito, France and Marianne were clearly outstanding exhibits.

everything possible about the dolls and their possessions in order to make a full, authentic record of their history. Originally they definitely made an impact on the historical and social as well as on the fashionable scene, at a time of immense international crisis. When it was decided to alter the arrangement of the dolls' case at Windsor, it seemed fitting that France and Marianne would then be reinstated in their rightful position, displayed as the most uniquely important dolls in the Royal Collection.

No other royal dolls have played such an interesting and important part in the state affairs of the two nations, France and England, and none can present to viewers today such a historic and comprehensive display of French haute couture in the last decade of elegance before the Second World War.

During the decade between the case's alteration and this book's completion, work was also done on other items which had belonged to generations of the Royal Family before coming into the care of the Royal Collection. Dolls, dolls' houses, their contents and other items in miniature made of silver, ceramic, wood and ivory – some of which dated back to the eighteenth century – needed to be sorted, listed and stored and, sometimes, conserved.

The days spent at Frogmore House on this project seem to me to have helped to maintain the well-being of the conservator as well as of the conserved artefacts. Its uniquely serene ambience and ever helpful staff were immensely beneficial then

and during the complicated research for this book. The assistance which has been so willingly and kindly provided by long-suffering friends and colleagues has also been invaluable. Without their support the difficulty of discovering all the facts about the dolls' Canadian tour would have been almost insuperable as most of the information was found only after exhaustive scanning of old Canadian newspapers and various minutes of charity committees' meetings.

Equally valuable were the actual French newspapers of 1938, especially *Le Journal*, which were found and bought for me in Paris. These sources are mentioned particularly because they provided accurate, contemporary accounts of events and enabled the story of France and Marianne to be compiled from facts and figures located abroad as well as in England.

One of the most stimulating aspects of research for me is that – although it may be tiring, sometimes frustrating and often exasperating – it has never lost its fascination. Serendipity rules. Searching the Royal Archives, hunting in the old newspapers and magazines at Colindale or Kew, or in books at libraries and museums, one could expect to find the odd piece of information – even though this expectation was not always fulfilled. But only the laws of serendipity account for finally finding unique photographs of royalty in a cupboard in an East End hospital, or a rare picture postcard of the dolls in a jumble sale. Many hitherto unrevealed facts and evidence of a few fantasies about the dolls are now on record. It is hoped that this book, with its copious illustrations, will be seen as a tribute to all those who were involved in the creation of two of 'the world's best-dressed dolls', France and Marianne.

To have been allowed to work for so long a period at Windsor Castle and at Frogmore House has, of course, been a great privilege, and I am deeply grateful to Her Majesty The Queen for granting me access to hitherto unpublished items in the Royal Archives and in the Royal Collection. I am grateful, too, to the Director of the Royal Collection, Sir Hugh Roberts, for encouraging me to publish the fruits of my research in book form.

FAITH EATON
LONDON, 2002

Beyond the dominant Round Tower, built on the site of William the Conqueror's keep, is the Upper Ward whose walls have contained the Royal Family's state and private apartments for over eight hundred years.

THE STORY OF FRANCE AND MARIANNE

At first glance the great castle towering over Windsor and the bordering River Thames looks so like a fairy-tale invention that it is difficult to believe it has an everyday existence. In fact, the castle fulfils a dual purpose as it is both a much loved royal residence and a famous historic landmark visited by thousands of people every year.

Among the many treasures on view there as part of the nation's heritage are a number of items originally presented to members of the Royal Family as gifts. One of the most famous is Queen Mary's Dolls' House, the superb miniature mansion that the country presented to the consort of King George V in 1924.

On display close to the Dolls' House, representing all the dolls in the Royal Collection, are two of the very finest, France and Marianne. Made in the internationally famous Jumeau factory in Paris, the dolls were presented as gifts for Princess Elizabeth and Princess Margaret Rose on the occasion of the State Visit to France of King George VI and Queen Elizabeth in 1938. One has only to look at the beautifully moulded heads of the dolls and the exquisite detail of their extensive trousseaux to be aware of their exceptional quality and attraction.

In order to understand the true significance of this remarkable state gift, the political and diplomatic situation in Europe at the time needs firmly to be borne in mind. For 1938 was a watershed year; it was a moment of crisis, when statesmen anticipating the inevitable war sought to strengthen ties with all potential allies, and it was to emphasise the importance of the *entente cordiale* between Britain and France that the new King and Queen's State Visit to Paris was arranged. The traditional ceremonial exchange of gifts took on an even deeper significance on this occasion. The names of the dolls given to the Princesses reflected the recognition of their national importance: 'France' was chosen to represent the host country and

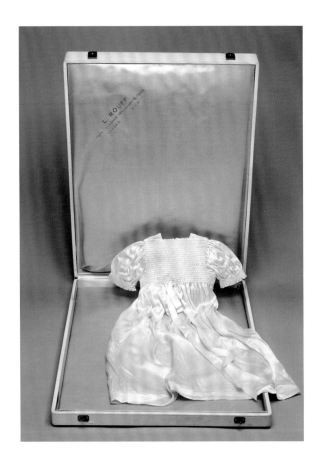

'Marianne' to recall its historic, symbolic figure of freedom.

Looking back, it may seem puzzling that at a time of deepening international tension so much attention should have been given to the making of two dolls, but Paris had for centuries been the centre of the fashion world. It was with the whole-hearted co-operation of the famous couturiers that what was later described by fashion writers as 'the most beautiful wardrobe of clothes in the world of dolls' was designed and made. The renowned establishments of haute couture welcomed the opportunity to demonstrate their skills and their taste, and all sought to contribute their very finest work. Tradition, national pride and sheer artistry combined to provide the most fitting gift for *la belle reine anglaise* to take back to her two young daughters.

Sixty years after they were made it is still easy to see why the dolls and their trousseaux made such an impact then upon the world of fashion, for their exquisite clothes were designed by the Parisian makers to provide a microcosm of haute couture in 1938.

One of a pair of beautifully smocked satin nightdresses made for the dolls by L. Rouff. The satin-lined leather case emphasises the importance that all the makers attached to the presentation of their gifts.

The diplomatic significance of this French state gift is, perhaps, a little less obvious today but, at the time of their making, this aspect of the dolls' creation was of considerable importance. Being officially designed to be presented to the young English Princesses, they became part of the French effort to strengthen not only the *entente cordiale*, but also France's most vital export, fashion.

In that uncertain year of 1938, and during the war years, the dolls raised thousands of pounds for charities coping with refugees and sick and deprived children. Indeed, perhaps the most astonishing part of France and Marianne's fascinating story is their wartime coast-to-coast Canadian fund-raising tour. That these two fragile royal dolls returned to England in 1946 undamaged, after so much travelling and so many exhibitions, is a wonder in itself.

Sixty years ago France and Marianne came over from France and appeared in London on exhibition at St James's Palace; sixty years on they are still 'on duty' in a royal residence, reminding many of a lost age of elegance and who knows? – perhaps inspiring a few to create their own images of beauty.

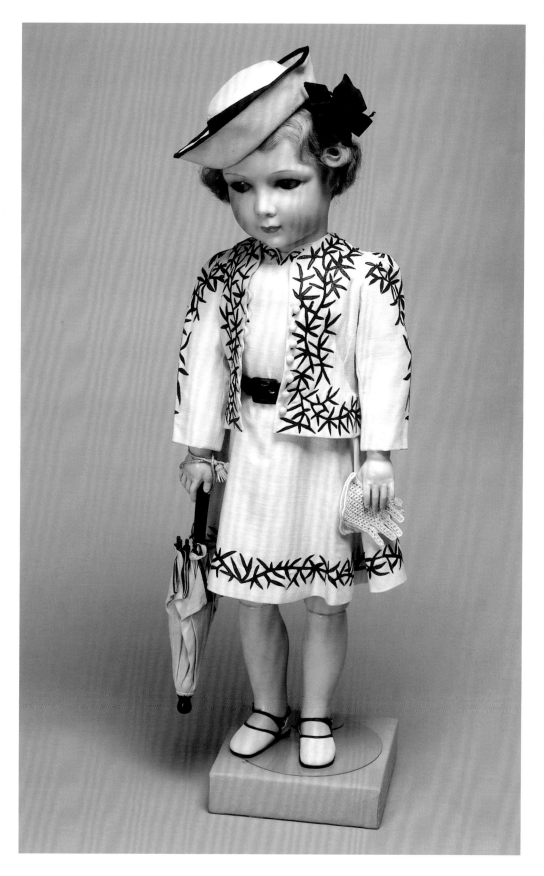

France's chic white linen dress and jacket, with navy-blue fern embroidery, were designed by Lucile Paray. The accessories were made specially for this outfit and the whole ensemble illustrates the care the makers took over all the items in the dolls' trousseaux.

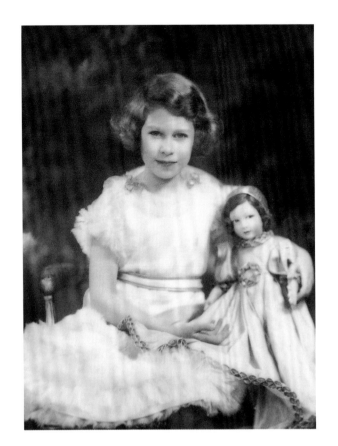

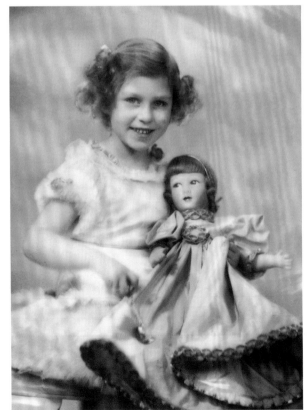

Historic gifts of dolls to royalty

For those interested in ancestry and historical associations, the family tree of France and Marianne provides a fascinating link both with recent history and with life at court in past centuries. As twentieth-century examples of 'fashion dolls' they are part of a tradition that goes back hundreds of years. Even as early as the fourteenth century, records show that dolls with trousseaux of fashionable clothes were presented to the daughters of English and European royalty. These costly gifts were commissioned either by members of the court or by foreign royalty and aristocracy and could be tokens of affection, esteem or diplomacy, depending on the circumstances of the donor. Their main objective was to establish, or further, a good relationship. They were, to borrow the traditional description used in Japan for such offerings, 'silent envoys', for it was not only in the western world that elegantly attired dolls were considered to be highly prestigious presents.

Regardless of the age of the recipient, fashion dolls that were sent as royal betrothal gifts were particularly appreciated. Dressed in miniature replicas of costumes in vogue at the recipient's intended husband's court, they were an invaluable guide for the makers of the bride's trousseau, and a way of ensuring that she would not arrive in her new country with any unfashionable outfits. Creating the right impression on such occasions was felt to be all important, even for such a self-confident princess as Marie de' Medici. 'Frontenac tells me,' wrote her bridegroom-to-be, Henri IV of France, 'that you wish to have samples of our fashions; I am therefore sending you several model dolls.'

It is to be hoped that the often very young royal child-brides who received such diplomatic gifts were also allowed to regard them as playthings. Even if a little princess was barely out of the nursery, it was often her fate to be the fiancée of a foreign monarch (whatever his age might be). A betrothal was considered to be a useful way of cementing an alliance between countries. It was certainly for political reasons that the English King Richard II – after the death of his beloved wife, Ann of Bohemia – consented to marry the 9-year-old daughter of the French King, Charles VI. What King Richard's betrothal gift to her was has not been recorded, but it is known that her mother, Queen Isabella, before her own marriage to the King of France, had asked for a fashionably dressed doll to be sent from Paris, 'that she might know the vogue currently worn at court'.

An interesting sidelight is also on record. Robert de Varennes, the court tailor who had been responsible for making this doll's trousseau, was instructed by

OPPOSITE: Princesses Elizabeth and Margaret Rose, each photographed with a doll in 1935.

OPPOSITE: This portrait of
Lady Arabella Stuart, by an
unknown artist, still hangs in
Hardwick Hall. Sadly, Lady Arabella
ended her life as a political
prisoner in the Tower of London.

Queen Isabella to make a second one some ten years later. This mannequin was sent by the Queen to England when her little daughter became the child-bride of King Richard in 1396; obviously Parisian haute couture was considered to outrank all other nations' fashions even in the fourteenth century.

There is uncertainty about the size of these dolls. Entries in various account books of the French court do suggest that some, at least, of these royal gifts were large, perhaps even life-size. They were described as 'dolls' or 'mannikins' (mannequins), but the terms were vaguely used and might mean a wooden or lay-figure in 1301, when the French King sent an example with a fashionable wardrobe of clothes to his daughter Isabella (another child-bride of a future English monarch), or a really 'big doll with springs, a well-made foot and a very good wig', a description supplied by Rose Bertin, who dressed the dolls ordered by Marie-Antoinette for her mother and sisters in Austria some five centuries later.

The fact that Robert de Varennes was paid 459 francs for the second trousseau ordered by Queen Isabella does lend weight to the large or life-size theory, for that would have been a substantial sum even for a full-size outfit in 1396.

Exactly a century later, Ann of Brittany, Queen of France, sent 'a great doll' to the Queen of Spain, yet another Isabella. The Spanish Queen was a mature 43 years old at the time and well known for her immense interest in *à la mode* attire. Unfortunately she was less than gratified with this example of haute couture and directed that it should be returned to Paris. What the reaction of the French Queen was is unknown, but it is recorded that the doll was re-dressed before it was sent back to Queen Isabella.

Not all these royal gifts were large-scale models of fashion. Orders for several sixteenth-century examples specify that a small size was to be provided. In 1571, for instance, the maker of the fashionably dressed doll created for the Duchess of Bavaria's infant daughter was instructed by the donor, Claude, Duchess of Lorraine, to remember the child's age and ensure that the doll would be a 'suitable size' for a baby.

A number of paintings show small, very elegantly dressed dolls with youthful owners. One charming English portrait of the 2-year-old Lady Arabella Stuart – painted in 1577 to hang in Hardwick Hall – depicts the elaborately and stiffly gowned little girl clutching an equally finely dressed but diminutive doll. Apparently this one at least was treated as a plaything. There are several instances recorded where a sumptuously costumed doll seems to have been regarded as a toy – though some may well have been played with only after they had fulfilled their role as mannequin.

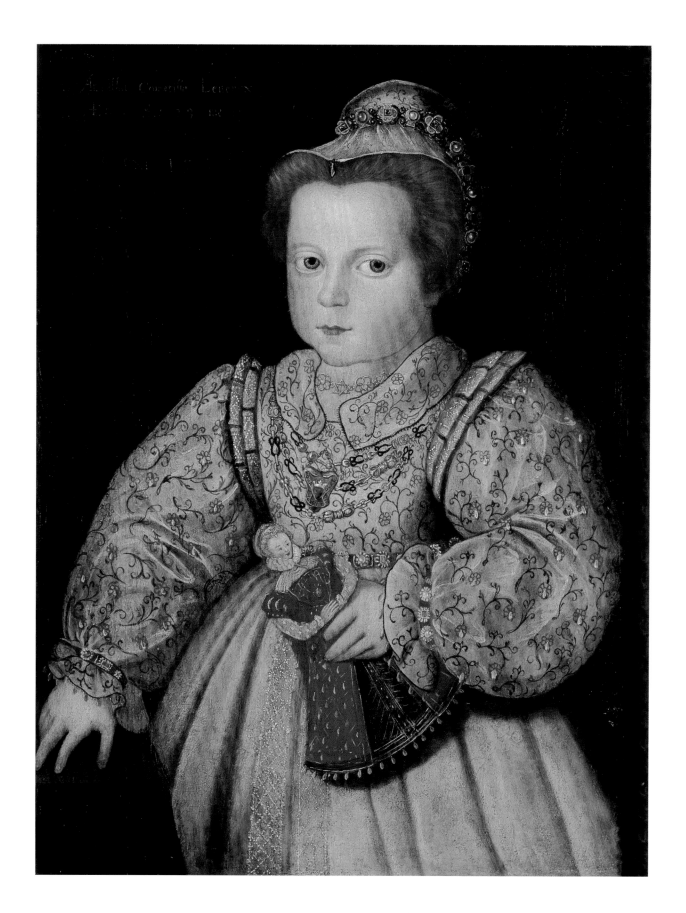

French royal children appear to have been particularly fortunate regarding their gifts in the sixteenth century. Henri II is recorded as having ordered six expensively dressed dolls for his children and Charles VI also paid a considerable sum for one especially fine doll for his daughter.

The Count d'Osni was another generous giver of presents for, when sending one young princess a very beautiful doll, he also dispatched a toy coach containing several dolls to her brother, the Dauphin (later Louis XIII). A rather intriguing note accompanied the Dauphin's gift. It described one of the dolls in the coach as being dressed 'as my mistress, the Infanta', an enigmatic comment which, at least, is evidence that boys as well as girls were given both female and male dolls as playthings.

In court circles the domination of Parisian couture had been recognised internationally for hundreds of years by the beginning of the eighteenth century. However, although in these earlier times it was the French court dressmakers and tailors who were renowned, by 1700 mannequin dolls, displaying the latest modes, were no longer being created solely for the exclusive benefit of royal and noble patrons.

So increasingly important was the role of such dolls in promoting French fashions abroad that not even a war was permitted to impede the export of examples from Parisian couturiers. By 1704 no less a personage than the distinguished writer Abbé Prévost recorded in his memoirs: 'By an act of gallantry, which is worthy of being noted in the chronicles of history, for the benefit of ladies the ministers of both courts [i.e. French and English] granted a special pass to those mannequins; that pass was always respected . . . and the mannequin was the one object which remained unmolested.'

As the eighteenth-century French journalist Mercier no doubt took pleasure in observing in his *Tableau de Paris*, 'the chic imparted to fashion by French hands is imitated by all nations, who obediently submit to the taste of the rue Saint-Honoré'. The greater availability of these mannequin dolls (now dressed not by a court tailor but at famous Parisian couturiers' establishments) did little to diminish the acceptability of such dolls as royal gifts. It was, as Monsieur Mercier noted, Parisian chic that was important, not necessarily the costumier.

In England during the nineteenth century the royal nursery accounts reveal some fascinating details about gifts purchased for various royal children. Curiously enough, most of them seem almost excessively modest birthday and Christmas presents – though doubtless these dolls and toys were received with far more

pleasure than the valuable objets d'art given at such times. What is clear during this century is that the need to present any royal princess with a costly, bespoke Parisian mannequin doll for any practical purpose had ended. This is not really surprising. Once well-illustrated fashion magazines could supply, quickly and cheaply, details of the latest designs from the trend-setting Parisian couturiers, there was no longer any reason for a doll to be dressed there in order to acquaint royalty with this erstwhile scarce and necessary information. Equally, it follows that there was no prestigious advantage to be gained by the giving of such a doll.

Queen Victoria's daughters and other young relatives were sometimes photographed, as well as painted, holding dolls that were expensively and fashionably dressed. However, these dolls, their extensive trousseaux of clothes and boxes of accessories were purchased from the growing number of specialist toy shops that were opening in both Paris and London.

Even the lovely Jumeau doll that Queen Victoria's granddaughter Princess Margaret of Connaught holds for her photograph is one of that famous firm of dollmakers' standard models, a 'little girl' doll wearing a replica of a child's fashionable dress. Though beautifully costumed, this doll merely records a fashionable youthful style. It cannot be compared in importance to the adult-figure mannequins made by the Parisian couturiers in previous times to promote their latest modes. For centuries such dolls had been valued for this practical purpose; but their involvement in this role, and therefore the reason for such gifts to royalty, ended in the nineteenth century.

Or so it seemed . . . until 1938, for in that year the traditional presentation to royal princesses of dolls in fashionable attire was revived, with magnificent style, when King George VI and Queen Elizabeth made their historic State Visit to the Republic of France and accepted for their young daughters, the Princess Elizabeth and Princess Margaret Rose, the gift of the two dolls France and Marianne.

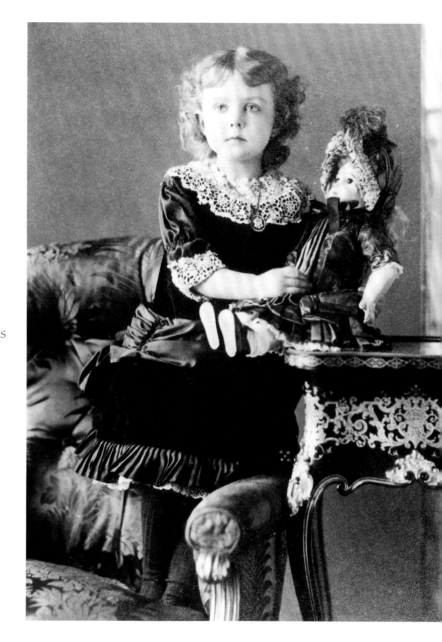

Princess Margaret of Connaught – daughter of Arthur, Duke of Connaught, and his wife Louise Margaret of Prussia – holds a typical Jumeau doll, costumed in the elaborate style worn by a fashionable little girl in 1886.

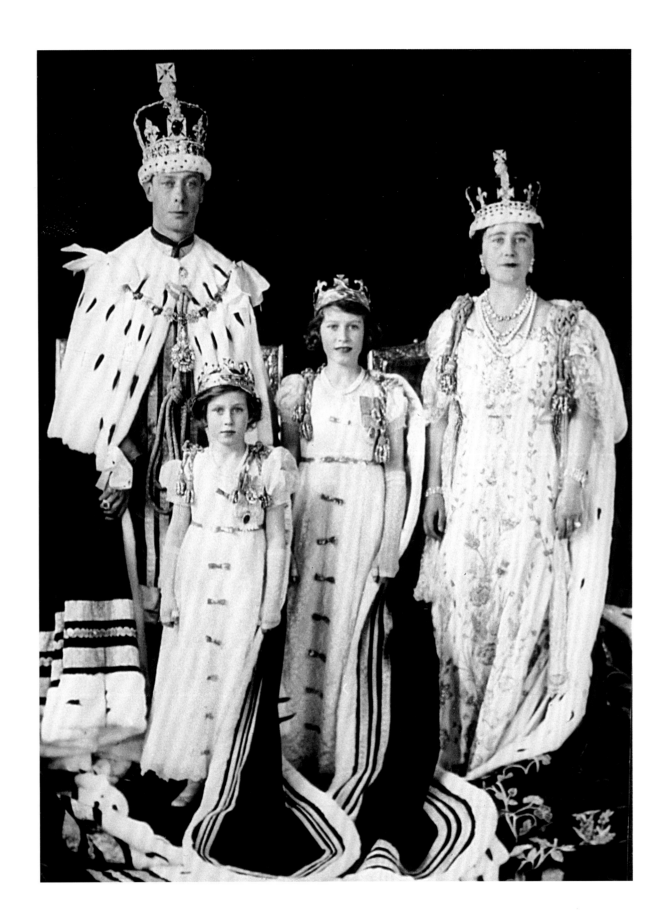

The royal visit to Paris in 1938

Although the Second World War did not begin until September 1939, there was a growing realisation throughout 1938 that conflict in Europe was inevitable and, in this last year of peace, preparations for war intensified.

Strengthening essential ties between Britain and her nearest potential ally, France, was seen to be of paramount importance. A State Visit by King George and Queen Elizabeth was therefore arranged to take place in Paris during July 1938. The fact that this visit was judged, on both sides of the Channel, to be an outstanding success was due in no small measure to Queen Elizabeth. Her gracious manner and personality were frequently commented upon; and her support of the King during the four strenuous days of the visit was of immense importance, particularly as he had barely recovered from an attack of influenza.

Queen Elizabeth's mother, the Countess of Strathmore, had died a month before the visit began, so Her Majesty had also to contend with personal grief at this stressful time. The Queen was of course observing full court mourning, and this meant that her carefully planned, colourful outfits could not be worn. Unrelieved black was felt to be inappropriate for a State Visit, and Norman Hartnell's inspired last-minute idea, for an all-white theme instead, resulted in a wardrobe that won universal admiration in that most couture-conscious city, Paris. During the visit her white ensembles, for both day and evening wear, were acclaimed and photographs of *la belle reine* appeared in numerous French and English newspapers and magazines.

There does not seem to be any mention of the creators of the clothes made for France and Marianne being presented to Her Majesty, but her outfits were no doubt especially interesting to the makers of the other most talked-about trousseaux in Paris.

The King and Queen had arrived in the capital by train; then, accompanied by President and Madame Lebrun, they had been driven in procession with a ceremonial mounted escort to the Palais du Quai d'Orsay. Here the state suite had been completely redecorated and furnished with priceless, historic pieces of furniture, paintings and objets d'art for the royal visit.

OPPOSITE: King George VI, Queen Elizabeth, Princess Elizabeth and Princess Margaret Rose, enrobed for the coronation in 1937. The new Royal Family re-established a feeling of stability at home at a time of great uncertainty abroad.

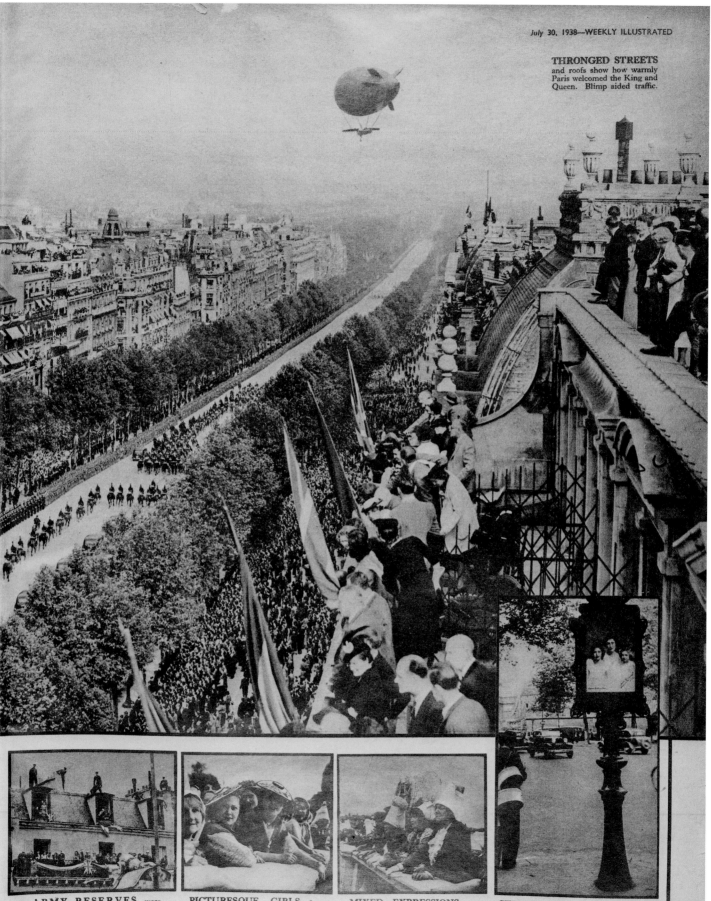

THRONGED STREETS and roofs show how warmly Paris welcomed the King and Queen. Blimp aided traffic.

ARMY RESERVES were posted on roofs and in attic windows as part of precautionary measures.

PICTURESQUE GIRLS from Nice, wearing traditional dress, are in high spirits while waiting to see Royal visitors sweep along in procession.

MIXED EXPRESSIONS as these Norman peasants, in all the glory of historic costumes, watch beginning of Royal procession.

STREET SCENE showing to what extent Paris went in decorations for highly exciting and emotional Royal visit.

OPPOSITE: On 17 July 1938 the King and Queen, accompanied by President and Madame Lebrun, drove in ceremonial procession through Paris to begin their highly significant and successful State Visit. The capital was *en fête* and the event, attracting an enormous response, resulted in a strengthening of the *entente cordiale* at a crucial time.

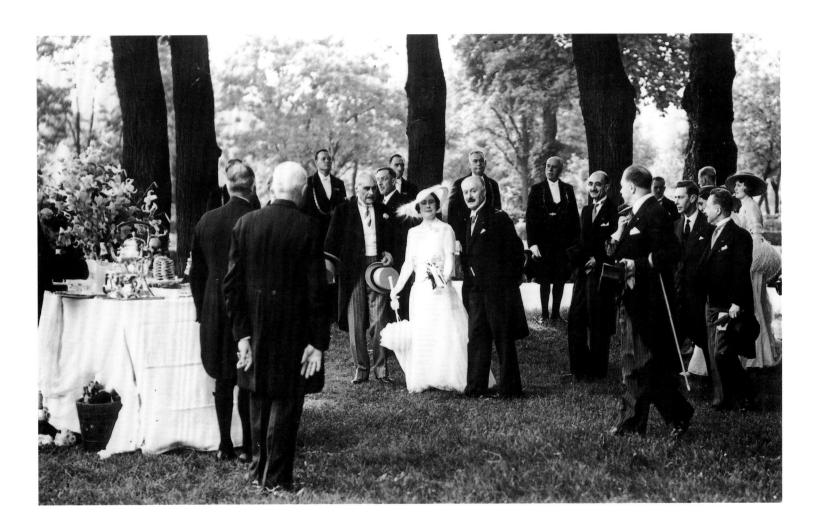

Norman Hartnell's inspired designs and choice of materials for Queen Elizabeth's famous all-white wardrobe for the State Visit attracted universal admiration.

The King and Queen are here shown arriving at the afternoon party given in their honour by the municipality of Paris in the garden of the Bagatelle on 20 July 1938.

THE ROYAL VISIT TO FRANCE: PREPARATIONS; GIFTS; AND A REHEARSAL.

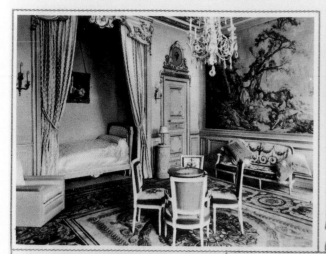

MEMBERS OF THE STAFF AT THE QUAI D'ORSAY PALACE, AT WHICH THE KING AND QUEEN STAYED: FOOTMEN; WITH A MAJOR-DOMO (CENTRE) CARRYING A HALBERD. (Topical.)

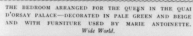

THE BEDROOM ARRANGED FOR THE QUEEN IN THE QUAI D'ORSAY PALACE—DECORATED IN PALE GREEN AND BEIGE AND WITH FURNITURE USED BY MARIE ANTOINETTE. Wide World.

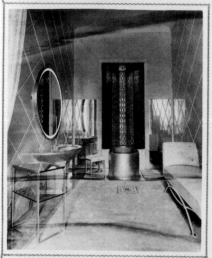

GIFTS OFFERED BY THE CHILDREN OF FRANCE FOR PRESENTATION TO PRINCESS ELIZABETH AND PRINCESS MARGARET: TWO DOLLS, "MARIANNE" AND "FRANCE," SEATED IN THE MODEL CARS (REPRODUCED STRICTLY TO SCALE AND PAINTED LIGHT GREEN AND PERIWINKLE BLUE RESPECTIVELY, WITH KID UPHOLSTERY) WHICH ARE INCLUDED IN THEIR EXTENSIVE BELONGINGS. (Barratt.)

IN THE BATHROOM PREPARED FOR THE QUEEN—WITH A BATH OF WHITE AND SILVER MOSAIC LET INTO AN ALCOVE PANELLED WITH FLUTED GLASS. (Wide World.)

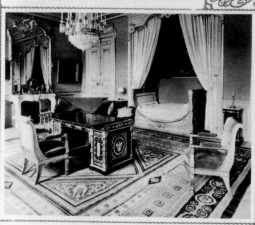

THE BEDROOM ARRANGED FOR THE KING IN THE QUAI D'ORSAY PALACE—SHOWING THE GILDED EMPIRE BEDSTEAD AND MAGNIFICENT MAHOGANY WRITING-DESK, WHICH WERE USED BY NAPOLEON. (Wide World.)

A REHEARSAL FOR THE ROYAL PROGRESS ALONG THE SEINE FROM THE QUAI D'ORSAY PALACE TO THE HÔTEL DE VILLE FOR A RECEPTION BY THE MUNICIPAL COUNCIL: THE ROYAL BARGE (CENTRE) ESCORTED BY NAVAL LAUNCHES. (Fox.)

In view of the State visit to Paris, the Quai d'Orsay Palace was completely modernised for the reception of the King and Queen. The work was supervised by the Foreign Minister, M. Bonnet; and his wife was largely responsible for the decoration of the room prepared for the Queen. The royal suite was directly above the reception halls and was hung with priceless tapestries and masterpieces from the Louvre and other sources. In the bedroom chosen for the Queen was a bed once used by Marie Antoinette; while in the apartment allotted to the King was a gilded Empire bedstead and a magnificent mahogany writing-desk used by Napoleon. Among the gifts offered for presentation to Princess Elizabeth and Princess Margaret were two dolls called "France" and "Marianne," with clothes and accessories specially made by the leading Paris fashion houses. The two trousseaux comprised some 350 objects. There were also the model cars shown in one of our photographs

Their Majesties' private suites, bedrooms, en-suite bathrooms, drawing rooms and ante-rooms surrounded a beautifully laid-out garden with a fountain set in the central lawn. Two sumptuous bathrooms had been specially constructed in the state suite and the choice of materials used, finest marble and either gold or silver and white mosaics, made both white-carpeted rooms unusually beautiful. All the original state reception rooms had been re-gilded and redecorated and hung with superb Gobelins tapestries. The Salle à l'Horloge became a temporary throne room complete with its own dais. All these rooms had the most magnificent chandeliers and the finest eighteenth-century furniture.

The fact that such a remarkable amount of actual construction – as well as redecoration and moving of specially selected pieces of furniture – had been undertaken to prepare accommodation deemed to be suitable for the four-day visit underlines the immense importance that the occasion had for both the host nation and the royal guests.

There would have been little time to relax in such exceptional surroundings, however. The crowded royal itinerary involved visits to a hospital, several exhibitions and official entertainments, a charity garden party, a matinée and a gala evening opera performance, a banquet and a spectacular costume ball.

In addition there were civil ceremonies at the Louvre and Hôtel de Ville, where the traditional presentation of official gifts took place. The city of Paris's gift to the King was an ornate monogrammed gold cigarette case and Queen Elizabeth received a Lalique glass dinner-service. For their two young daughters, who did not accompany their parents to France, there were also presents: a selection of specially chosen examples of French literature in twenty blue leather-bound books had been decided on for Princess Elizabeth; and toys, which included a child-size florist's shop, for the younger Princess Margaret Rose.

But of course it was the Princesses' gift from 'the children of France' that commanded the fascinated attention of both the French public and

OPPOSITE: Of all the beautiful rooms in the Palais du Quai d'Orsay's royal suite, which had been specially redesigned for the State Visit, Queen Elizabeth's bedroom was of particular interest as the furniture had once belonged to Marie-Antoinette.

Queen Elizabeth is greeted by President Lebrun.

the international press. The dolls, France and Marianne, with their possessions – ranging from cars, perambulators and cots to the jewellery and fans that complemented their exquisite trousseaux and were presented in satin-covered monogrammed boxes and leather cases – were of such superb quality that they have an unrivalled place of honour in the history of royal gifts of dolls.

The presentation was made during the ceremony at the Hôtel de Ville on 20 July 1938. On that day the most publicised dolls in the Republic of France became royal dolls belonging to the King of England's daughters.

A contemporary photograph captures the full extent of the royal gift.

Le Journal reports on the making of the dolls

It may seem surprising that any fourteenth-century reason for choosing dolls as a royal gift should still be relevant in the twentieth century, but two considerations were not only valid but important: tradition and practical use.

From the diplomatic point of view, it would be a bonus if all age groups could relate to the State Visit, and one thing that would stimulate the interest of children on both sides of the Channel had to be dolls, the traditional gift for princesses.

In Paris considerable interest was shown in the Princesses' present by both artistic and commercial entrepreneurs when the idea was first mentioned – so much, in fact, that the escalating enthusiasm of potential donors had to be curtailed.

Strict protocol governed the receiving of gifts by English royalty and, in order that they might not be felt to be favouring any particular giver, some suggested presents often had to be declined. Official gifts from rulers or governments and presentations made on behalf of places that were being visited were in a special category. However, the acceptance of one gift from a commercial enterprise might well cause offence if another firm's offering had to be refused. It was often impossible to accept everything. On this occasion amongst the items proposed as gifts that had to be tactfully declined were several dolls in national or regional French costumes.

One suggestion, to revive the traditional offering of French dolls with fashionable trousseaux, was felt to be particularly appealing, for French influence on international haute couture would be subtly emphasised by such a prestigious gift. Appropriate as fashion dolls would be, there remained the difficulty of protocol; to favour one couturier above others would be an unacceptable embarrassment and might preclude the acceptance of the proposed gift.

Careful negotiation eventually resulted in the offer, and agreed acceptance, of two dolls whose trousseaux would include items from all the leading fashion houses. They would be presented to the two little English Princesses as 'the gift of the children of France' by Madame Georges

Madame Georges Bonnet, wife of France's Foreign Minister, was called 'the generous godmother' of the dolls; the children's charity that benefited from their Parisian exhibition was chosen by Madame Bonnet.

ÉDITION DE 5 HEURES

LE JOURNAL

0,50

(N° 16652)

PARIS, 100, RUE DE RICHELIEU
Téléph. : Richelieu 81-54 et la suite

Mardi 24 Mai 1938

COURRIER DES POUPÉES

Le magnifique trousseau de France et de Marianne

France et Marianne ont reçu tant de cadeaux à domicile que nous passons notre matinée à défaire des paquets. Le papier de soie crisse de façon prometteuse, cartons et écrins s'entrouvent. Nous faisons un voyage féerique au pays de petits riens. Lespicat s'est spécialisé pour les boutonnières. Nous en voyons dans toutes les teintes, bouquets de pâquerettes et de roses mousse, assemblage de fleurs champêtres, coquelicots et marguerites, œillets solitaires pour égayer le strict tailleur, muguets, tombant en cascades — bleuets vifs et pâles myosotis — que de nuances, que de gammes, que de fraîcheur! La Maison Trousselier, n'est pas en reste, bien au contraire ; nous trouvons, dans ses nombreux cartons, des colliers de fleurs mêlées, une coiffure de myosotis, une autre de fleurs des champs et de folles avoines, un bouquet romantique de myosotis roses et bleus, une encolure en roses stylisées encadrées de lilas d'or, une ceinture de fleurs d'organdi, roses bleues amande et blanc, avec myosotis en trois tons, un piquet de corsage d'aubépine et de merises, un semis de fleurs de jasmin !

Nous en passons, hélas ! Nous en passons beaucoup, les deux maisons ont été si généreuses, mais nos filles sont impatientes ! Les voici déjà en contemplation devant deux couvertures de voiture en satin blanc piqué, doublé d'agneau et ornées de leurs initiales que vient de leur envoyer sa maison Mussis. Elles déballent quatre éventails, dont deux de chez Duvelleroy, en plumes d'autruche vieux rose, et turquoise montées sur des manches de nacre, et deux autres délicieusement peints par Marie Laurencin, montés sur de l'ivoire incrusté. Ainsi devaient être les éventails qu'emportaient sagement à leurs sauteries juvéniles, les petites filles modèles de Mme de Ségur.

France et Marianne, quand elles nous auront quittés, n'oublieront pas, au milieu de leurs plaisirs, leurs petits amis de France. Elles ont promis de nous écrire. Aussi la maison Maquet leur a-t-elle offert des buvards mignons en maroquin rose et en maroquin bleu, avec chiffres et couronnes de princesses, du papier à lettre chiffré, lui aussi, et de minuscules stylos en or.

— Vous écrirez, mes poupées ?

— Oh ! oui, mais voyez encore ! Et nous tirons du savant emballage de la maison Henri à la Pensée, deux écharpes sur lesquelles gambadent les 7 nains de Blanche-Neige, des mouchoirs en crêpe georgette, peints de roses et de roses bleues, de petites ceintures de cuir,

incrustées de porte-bonheur en argent, des sacs du soir perlés, rebrodés de coraux nacrés et rose vif, une ombrelle verte à tête de chien, une ombrelle jaune, une ombrelle en organdi turquoise, une autre rose, deux petits parapluies blancs huilés, et enfin deux maillots de bain l'un jaune, l'autre pervenche, dernier cri de la mode parisienne. On s'amusera bien, cet été, au bord de la mer. Quelle joie de se dorer au soleil.

Le soir évidemment il faudra s'habiller.

A cet effet, Chalom nous a offert des robes de tulle ocré, incrustées de valenciennes et brodées de ruches de dentelles, les dessous tout roses, de charmants boléros complètent l'ensemble.

Oh ! et nous sommes riches en dentelles ; encore Monsieur Dognin a bien fait les choses. Admirez ce mouchoir en Alençon, cette écharpe en point à l'aiguille, et ce fichu de bergère élégante en malines !

Et les petites coussettes avec leurs dés en or, que nous ont donnés Keller, et la maroquinerie de chez Hermès! Deux sacs si élégants l'un en box acajou, l'autre en porc naturel, contenant porte-monnaie, poudriers et petites glaces...

Vous avez tout vu, tout bien regardé, mes petites-filles ? Alors habillez-vous et venez aux Mille et une Nuits, car la question du linge n'est pas encore résolue, on a dû s'en apercevoir. Allons, ne vous poussez pas du coude, je sais bien qu'il ne faut pas parler de culottes en Angleterre, encore faut-il en avoir.

Ce sont deux ravissantes parures en mousseline de soie rose, avec incrustations et dentelles ocrées, chemise-pantalon et combinaison formant jupon, et deux autres parures en crêpe de chine brodé à la main, et garnies de véritables valenciennes, puis une douzaine de mouchoirs en dentelles où sont tracés les noms de nos poupées. Il y a aussi deux robes de petites filles, tulle et mousseline combinés, large voilant entourant le décolleté, plissé de tulle dans le bas, le tout sur un transparent rose pâle.

Sont-elles gâtées ces enfants ! Et elles inspectent pour finir deux berceaux roulotte en bois laqué bleus et roses, garnis crêpe de chine ouatiné et crêpe Géo, et deux petites voitures bleu marine, dont l'une est doublée de blanc, modèles caractéristiques de la fabrication française que leur destine Le Nouveau Né.

Ah ! ce départ sera un véritable déménagement — que de choses, que de choses? — et comme nous serons tristes quand elles nous auront quittées. Mais nous les gardons quelques jours encore... Nos courses ne sont pas finies — heureusement.

Expéditeur : **LE JOURNAL** 100 Rue de Richelieu, PARIS

Personnel

Messieurs et mesdemoiselles
les enfants de France
à PARTOUT

FRANCE

Mes chers enfants,

Paris fait sa toilette pour recevoir bientôt les souverains anglais.

On plante des roses. On décore les rues. On prépare des fêtes. Les cuisiniers officiels inventent des plats nouveaux.

Enfin, Paris mettra son costume d'apparat.

Tout n'est que joie, et promesses de joies, et pourtant, vous n'êtes pas très contents.

Les petites princesses viendront-elles ? avez-vous demandé ; et vos parents n'ont pas pu vous dire oui.

Puisqu'il n'est pas sûr qu'on puisse les amener jusqu'à Paris, nous avons cherché un moyen de leur envoyer le meilleur de Paris.

Comment ?

En leur faisant porter deux poupées mais deux extraordinaires poupées !

C'est nous, c'est vous, c'est toute la France qui va les donner aux princesses Elisabeth et Margaret-Rose.

De quelle façon ?

Vous le saurez demain en lisant dans Le Journal

{ UN CONTE DE FÉES }

ENFANTS DE FRANCE
Voulez-vous une belle histoire ?

ANDRÉ HELLÉ

Lisez en 2e page : UN CONTE DE FÉES

||| Et... grâce à vous, deux belles poupées de chez nous seront reçues à la Cour des princesses d'Angleterre

The dolls' sponsor, *Le Journal*, gave daily reports on the making of the trousseaux. Although its initial presentation was aimed to attract children, enough serious facts were included thereafter to ensure adults' interest.

Bonnet, wife of the Foreign Minister, who was herself an enthusiastic supporter of the project.

This auspicious agreement was not finalised until June. It must have come as an enormous relief to the anxious organisers who, perforce, had been working on the dolls and their clothes for some months in order to have them ready for presentation during the State Visit, which was to take place in July. Also, the general public, unaware of all these difficulties, had begun reading detailed reports about the dolls and the making of their possessions in one of Paris's premier newspapers, *Le Journal*.

Le Journal's director was the dolls' chief sponsor and his newspaper first broke the news of the intended gift on 24 May. In a front-page 'letter', 'the children of France' were told that, as the little English Princesses would not be accompanying their parents to Paris, two 'amazing' dolls would be sent to them instead. The letter also informed them that in the next day's newspaper they could read 'The Fairy-tale' which would begin the story of the dolls.

Le Journal of 25 May printed 'The Fairy-tale', a fantasy that introduced royalty and the dolls in a manner designed to appeal to younger readers. It then suggested a way in which the children might make this dream come true. Soon, they were informed, big money-boxes would appear all over France. If they contributed a franc, or even a sou, the dolls and their wonderful trousseaux would become their very own gift to the Princesses. Later on, all who had made a contribution could claim a photograph of the dolls as a souvenir.

The blend of fact and fantasy in 'The Fairy-tale' continued in all *Le Journal*'s daily reports. Written for young readers and entitled 'Courrier des Poupées' (Doll News), they subsequently covered the details of the unique present.

Although factual information was given about the making of all their possessions, the dolls themselves were often presented as real children. The imagined reactions of 'our daughters' to their clothes during their numerous visits to the couturiers were frequently reported as real children's behaviour – though, occasionally, readers were told that, as at the house of Lanvin, dressmakers, designers and dressers all fussed round our two little girl *dolls*.

Adult readers perhaps might find this irritating, but *Le Journal* realised that children accept and enjoy a mixture of real and imagined activities. Used to French fairy-tales, to 'real' Alice's adventures through the looking glass and to 'unreal' Peter Pan's appearances at the Darlings' nursery, they would not be confused.

Le Journal assumed that their young readers would be able to understand and appreciate the dolls' dual roles in their fantasy story – whether they were portrayed

as 'our daughters, the ambassadresses', preparing for their life in a royal palace; or as the 'best-dressed dolls in the world', being equipped with their superb trousseaux.

'In a garden full of greenery at the end of which stands a cheerful-looking factory where every day of the year little porcelain girls and boys are born, I have seen the two dolls that will be our ambassadresses', wrote the special correspondent for 'Courrier des Poupées' on 14 June. The description of their hair, eyes and facial colouring and body-shapes that followed was purely factual. A similar dichotomy occurred when the newspapers' reports of the dolls' activities were illustrated with photographs of the real-life seamstresses and designers at work on the trousseaux.

Young readers had already responded enthusiastically to *Le Journal*'s invitation to suggest names for the two dolls. On 2 June they learnt that the highest number of votes had been for 'France' and 'Marianne', names that the newspaper was happy to approve for 'their daughters'. Marianne, they were told later, was the elder and thought to look more mischievous than France, whose 'eyes were a little sad' sometimes.

All the couturiers' houses involved in making the trousseaux took immense pride in their project. At Lanvin seamstresses were photographed as they examined the latest dresses to be completed.

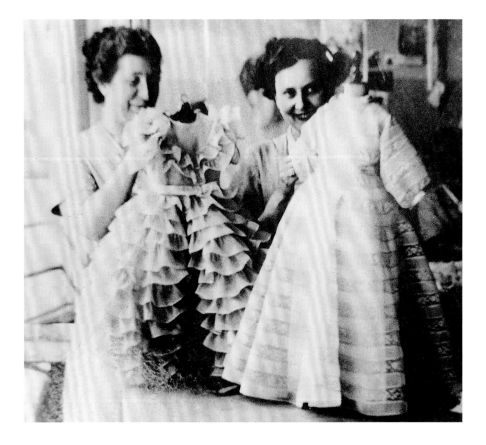

Unlike similar commissions for royalty in previous centuries, this gift of miniature mannequins in 1938 was of more practical benefit to the designers than to the recipients of the fashion dolls. The enormous publicity that the designers gained through the presentation added greatly to the prestige of the individual couturiers and also, of course, helped to emphasise the influence Paris continued to have on international fashion. As a promotion scheme it was of unique importance and value to French fashion houses. Several times *Le Journal* gave full credit to 'Paris's world-famous couturiers' for their generous assistance.

France and Marianne made almost daily visits to their couturiers and the 'Courrier des Poupées' article informed readers on 17 June they 'were completely bowled over,

OPPOSITE: France in a hyacinth-blue ensemble and Marianne in a pink outfit, both of which were designed by Lanvin. Each dress in the trousseaux had its own matching shoes and gloves and, where suitable, hats and accessories.

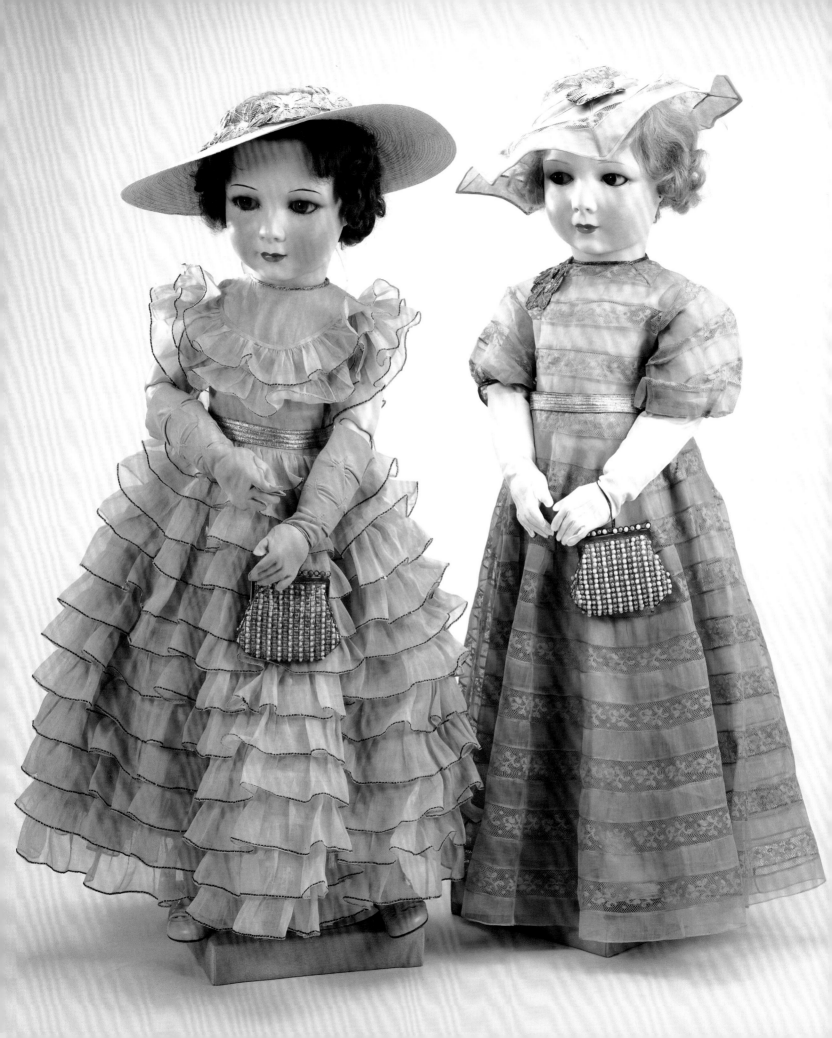

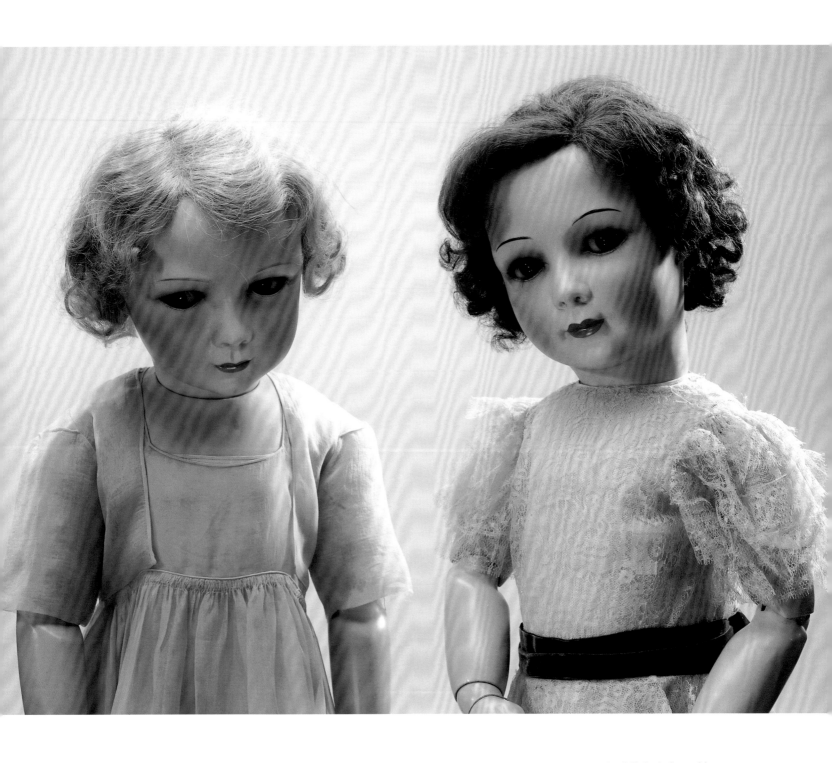

The dolls had identical bisque heads; however, their individuality was emphasised by their different hair and eye colouring. The custom-made brown eyes of France were thought to be wistful and Marianne's blue eyes to give her a more mischievous look.

wide-eyed and open-mouthed at Marcel Rochas' (and sulky at Lanvin, because they both wanted the same two dresses). The reporters were at pains to include, for older readers, serious and detailed descriptions of the lingerie, day and sportswear, garden-party and evening dresses designed for them by the fashion houses named. This particular account also mentioned some of the possessions being prepared for the dolls: table-linen from Maison Rouff and jewellery from Cartier.

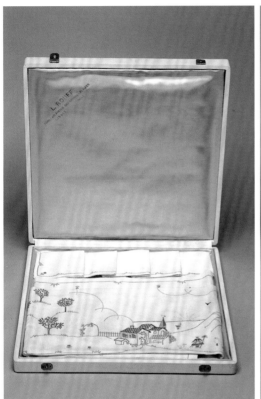

The trousseaux included several specially made possessions. Each of these cases of table-linen contained a hand-embroidered cloth and set of six matching napkins from L. Rouff.

This combination of factual and fantastic elements ensured that the interest of both adults and children in the project was maintained. By mid June more details were given of the sumptuous fur coats and cloaks, the many hats and pairs of shoes and gloves that by then had been added to the trousseaux. Children's imagination was also stimulated by reading about the dolls' reaction to their beautiful outfits. Marianne rushes off to try on hats, which she finds irresistible. France says her velvet beret is 'smashing'. ('Oh no, my little France,' she is admonished, 'don't use words like that, we have much better things to export to England!')

On 17 June both dolls are promised ice creams after they leave the couturier Patou: 'but is this reward necessary? Isn't it enough to revolutionise Parisian haute

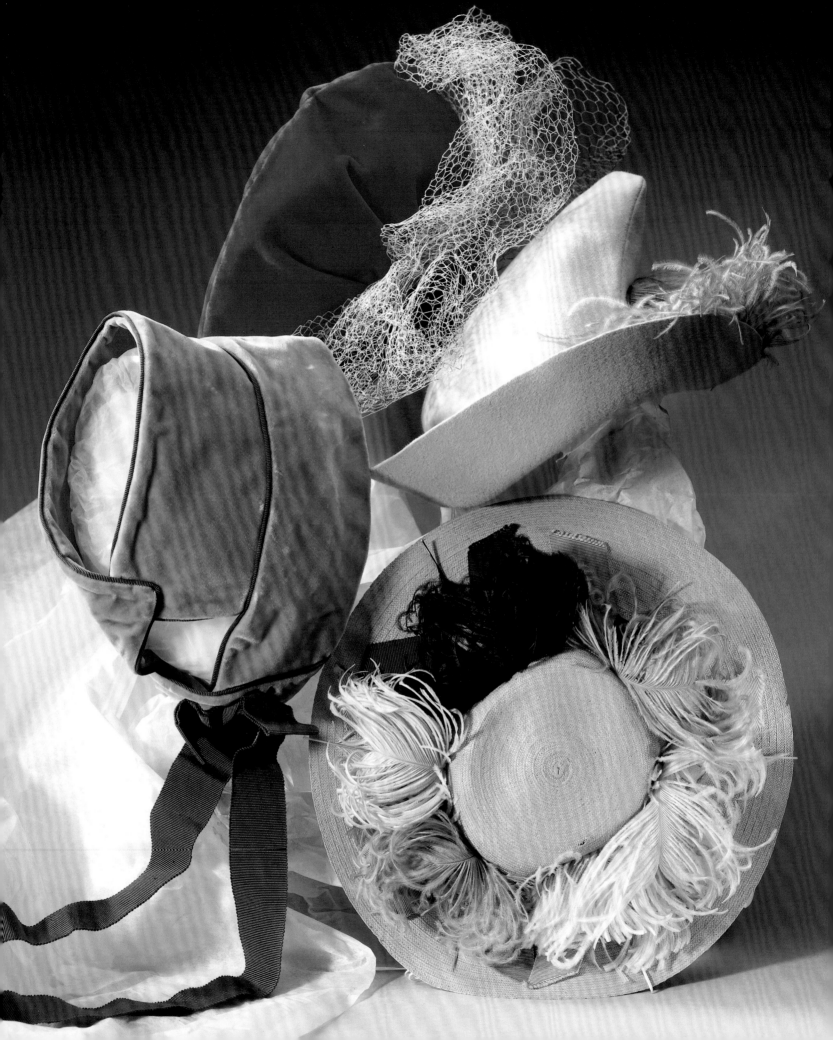

couture? How many elegant women are going to queue up for new costumes because of you?' This gentle hint to adult readers of the report is perhaps inserted because, whimsical though they might seem at times, the writers never forgot that the main purpose of the dolls' exquisite trousseaux was to promote French fashion.

Like the couturiers creating the dolls' unique trousseaux, the writers realised that these miniature garments' designs could have an influence on forthcoming fashions for full-size clients. Unlike today, when individual preference is all important when choosing what to wear, before the Second World War the season's vogues were shown by the leading couture houses and decreed by the fashion writers. The medieval sumptuary laws governing the colours and the quality of materials that could be worn in the various strata of society no longer applied, but the upper classes still had their own rules. Care was taken to provide France and Marianne with all the changes of clothing that would be needed around the clock.

Even many who were not in the upper echelons of society changed two or three times a day: from morning to a more formal afternoon outfit, then to dinner or evening dress. Hats, gloves and appropriate shoes were not seen as accessories, but rather as essential parts of the whole ensemble. France and Marianne would need to have nightdresses, negligées and lingerie of all kinds; and suitable outfits for morning activities, luncheon, afternoon visiting, tea, cocktail and garden parties, theatres, dinners and balls. They would also need fur coats for daywear and white ermine cloaks for the evening.

Fabrics in the 1930s were mostly soft and clinging, and crêpes, silks and satins, voiles and lace were often cut on the cross to achieve the desired long, slim look. No Edwardian lady could have managed to lace her wasp-waisted corsets or cope with back-fastening long dresses and elaborate hair-styles without assistance. Even though the clothes of a fashionable lady in 1938 would appear less constricting and much simpler in style, she would still need an experienced personal maid, if only to keep her delicate wardrobe in perfect condition. Having acquired the necessary

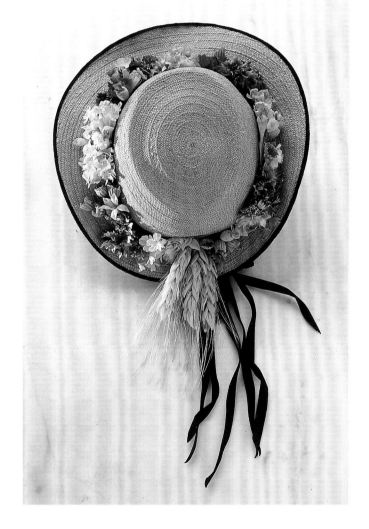

When designing this charming straw hat Hortense was inspired by a traditional French peasant custom of presenting visiting dignitaries with red, white and blue wild flowers and wheat ears.

garments, it was essential that every item should look immaculate in order to achieve that vital effect, elegance.

Some of the ensembles described for France and Marianne were miniature replicas of the latest modes designed by the couturiers and some were originals created solely to be worn by the dolls – one of the latter being the elegant *robe de chambre* made from a length of lime-green silk fabric used to cover the walls of the Queen's bedroom in the Palais du Quai d'Orsay. All these clothes were made and embroidered by the most experienced needlewomen of their houses. Every couturier was determined that the items which bore their labels would enhance their reputation.

The 'Courrier des Poupées' promised the children that they would be able to see the dolls and all their possessions on exhibition in Paris before they were given to the King and Queen for their daughters. On 27 June *Le Journal* did not publish the usual latest news of the dolls' trousseaux but instead printed another letter:

The milliner Jane Blanchot and Suzanne Joly – who specialised in fine lingerie – both chose to stitch their normal-size labels to items they created for the dolls' trousseaux.

OPPOSITE: Several trousseaux items were not only unique in design but also in materials. Some were made from fabrics specially woven for the garment, but this Charmis housecoat was made from a piece of the lime-green silk wall-covering in Queen Elizabeth's Paris bedroom.

My dear children, for several weeks we have gone from one happy surprise to another. No sooner had we announced that two dolls, of a beauty that normally one would only glimpse in a dream, would go to bear the testimony of your respectful friendship to the little royal Princesses of England than, quite spontaneously, with courtesy and enthusiasm in equal measure, all the great houses of French fashion put themselves at our disposal . . . so what should we do with the money that, sou by sou, built up in our collecting-boxes thanks to your generosity, dear little children? The collecting-boxes from Paris have already been opened in the presence of Monsieur Lejeune JP, the ones from the provinces will be soon; and the whole of the contents of all these boxes will be sent in your name to the Day Nursery of the Mutual Aid Society of the Women of France, a social service which Madame Georges Bonnet, the good fairy and generous godmother of France and Marianne, was kind enough to suggest . . . we also want to take this opportunity to convey our deepest and sincerest thanks to the famous leaders of the great Parisian houses, the designers of the trousseaux for France and Marianne and the people who made them, and all our friends who have helped us to set this project in motion.

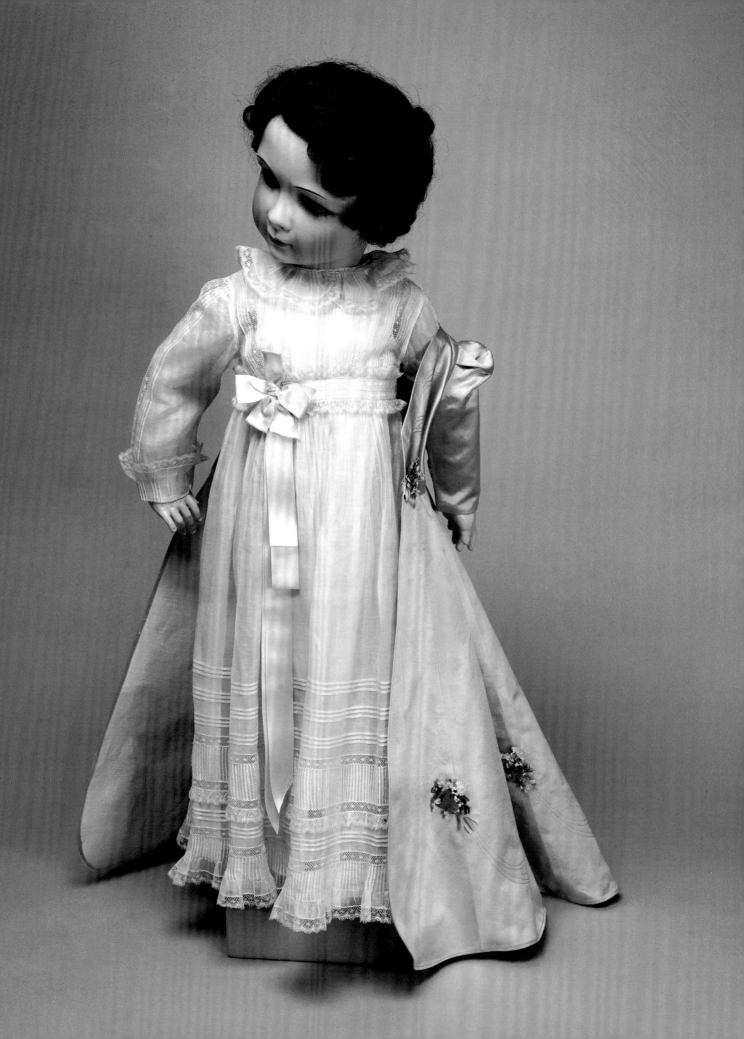

The following day normal reporting was resumed. The dolls tried on even more hats, hugged each other for joy when they saw the jewellery Cartier gave them, and went to the Citroën works to see their cars: 'no, they have not got their licences, these are royal dolls and they will drive in Windsor Park, where everyone knows them'. Unfortunately, the cars were not quite ready, so there was a slight delay before the two superb miniature sports cars (and also the promised beautiful bottles of perfume from the best-known perfumiers and the boxes of dainty parasols from Henri à la Pensée) could be delivered.

There was an interesting footnote to this 28 June report, which gave publicity not to clothes but to two modern textiles. Included in the dolls' trousseaux would be: 'dresses and coats of Albene and Rhodia . . . for French dolls have inherited the taste of their little mothers, these little girls who base theirs on that of their mothers,

Duvelleroy provided four fans for the trousseaux. The leaves of two of them were painted by Marie Laurencin, her delicate doll-like trio of figures being particularly charming.

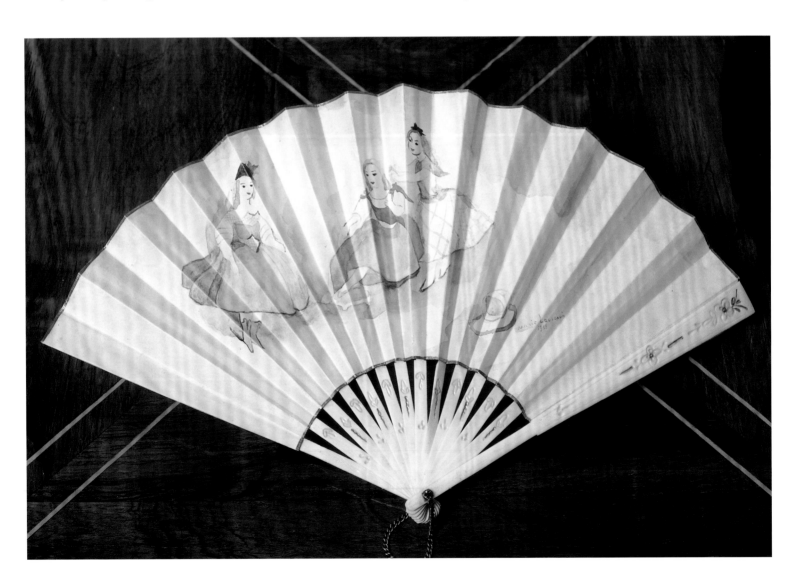

the elegant women of Paris'. The fashion houses were undoubtedly keen to include the most up-to-date materials in the range of fabrics they chose.

Just a few days before the State Visit, the complex and unique project was completed and *Le Journal* was able to announce:

France and Marianne . . . will be exhibited, complete with their splendid trousseaux, tomorrow, Saturday 16 July and Sunday 17 July at the Marigny Theatre, at Marigny Circus. Tomorrow will attract a small fee, entrance will be 3 francs per person and all proceeds will go to the nursery work of the Mutual Aid Society of the Women of France. Entrance to the exhibition will be from 10am to 7pm inclusive. On Sunday 17 July the exhibition will be free and entry will be from 9am to 7pm inclusive. How beautiful our dolls are going to be when all the great dressmakers . . . that your mothers dream about, and you will also dream of, have put on the dolls all their finery.

The entire French press next day seemed to carry photographs and descriptions of this spectacular display, which was universally praised as a 'magnificent gift for the English Princesses'. One paper, *Le Petit Parisien*, did in a sense break rank – but only to the extent that it described the King and Queen as British instead of English, the term generally used at that time. Marianne's name was also altered, to the hyphenated Marie-Anne.

Having been particularly involved in the project, *Le Journal* must have been as gratified by the public's reaction to the display as they had been earlier by the makers' generosity and help.

A dream ('The Fairy-tale') had begun the newspaper's accounts and 'wanting to bring this dream to life' in the best conditions for success, *Le Journal* turned for support 'to the most conspicuous stars in the Paris galaxy. These, in a gesture that serves to emphasise their elegance, told us they would love to give their trousseaux to the Princesses' dolls.' There followed a list of all the items displayed at the Marigny Theatre:

natty hats from Agnès, Marie Aubert and Rose Descat and the dashing bonnets of Maria Guy, Le Monnier, Caroline Reboux and Suzy; pearls and diamonds from Cartier, sables from Max and Weil and Jungmann; fans from Duvelleroy and two painted by Marie Laurencin; heady perfumes from Bourjois, Coty, Guerlain, Houbigant, Lancôme, Pinaud and Weil and shoes from Hellstern.

Alexandrine and Perrin will provide gloves for the two porcelain nymphs and Valentin will style their hair . . . Charmis, the Grande Maison de Blanc, Aux Mille et Une Nuits, L. Rouff and Valisère will contribute their most delicate lingerie, their costliest lace, their accessories.

Twenty-eight dresses, for evening wear, for the afternoon, for the house, for the beach, for cocktails, for the races, for formal events . . . bear the greatest names of Parisian haute couture: Bruyère, Chalom, S. Joly, Jeanne Lanvin, Lucien Lelong, Maggy Rouff, Paquin, Lucile Paray, Jean Patou, Robert Piguet, Marcel Rochas, Madeleine Vionnet, Jacques Worth.

Not wanting to leave out any of the craftsmen in this success we still have to mention Trousselier and Lespiant who will provide artificial flowers; Leda for raincoats; La Maison Aux Tortues [the tortoises] for their hair-dressing sets; Mussis for coverings [rugs etc.]; Henri à la Pensée for parasols, umbrellas, bags and belts; Hermès for handbags, also Masson and Duvelleroy; Vuitton for luggage; Keller for sewing kits; Maquet for fine leather goods and Le Nouveau Né for prams and cots.

Citroën will give each of the dolls a splendid car. Paris, in its excitement and enthusiasm, has put together the world's most magnificent trousseaux for the pretty eyes of two royal children!

Henri à la Pensée contributed two leather belts, with charming metal detail, in addition to four umbrellas.

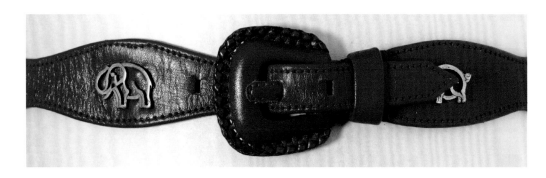

OPPOSITE: One of Duvelleroy's ostrich-feather fans, a wreath of flowers from Trousselier, satin shoes by Hellstern, gloves by Alexandrine, Henri à la Pensée beaded evening bag and a hat from Lanvin, displayed on one of Duvelleroy's satin-covered boxes.

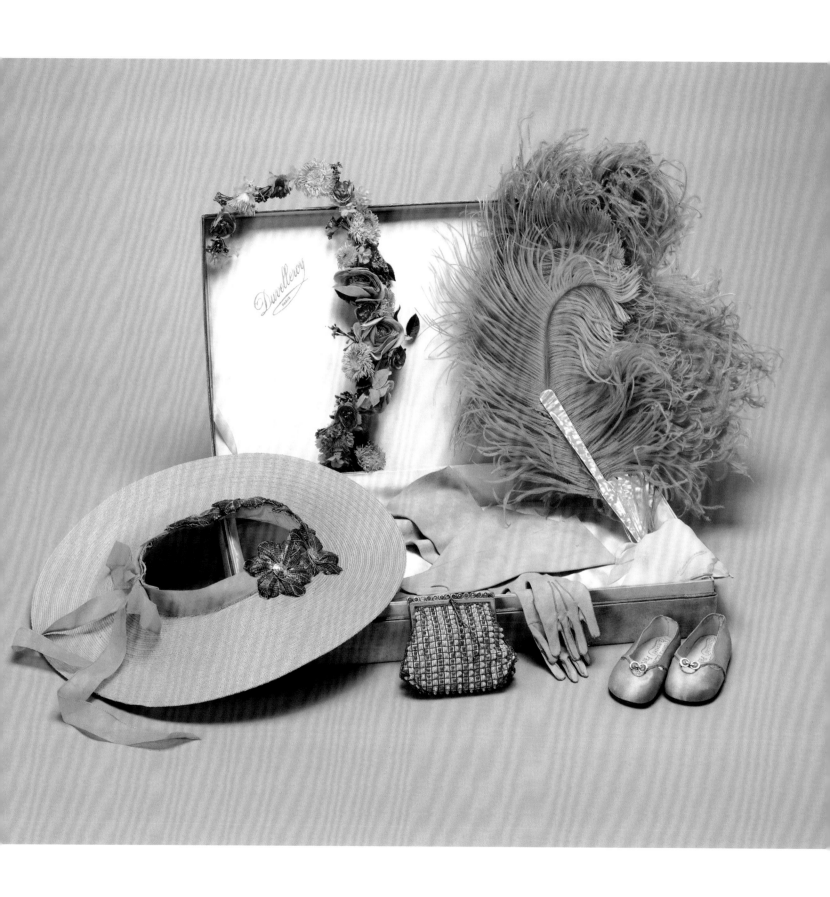

The reference to Duvelleroy as a supplier of handbags is surprising, and no evidence has been found to support it. Also, despite 'not wanting to leave out any of the craftsmen', there is no mention of the great doll-making firm, Jumeau, whose craftsmen had produced France and Marianne. One or two makers' names are missing because their contributions were amongst the last items to arrive; however, the complete list of every item displayed is to be found in the catalogue of the exhibition at St James's Palace (see pages 123–30). Of all the houses appearing on the list only four – Lanvin, Vuitton, Hermès and Cartier – still produce the items for which they were renowned over sixty years ago. But in July 1938 all were important to the fame of Paris as the centre of haute couture.

Although the dolls were made by Jumeau craftsmen, the names of the makers are unfortunately unknown. All the attention was given to the trousseaux makers, and the creators of France and Marianne were not identified.

Over the weekend of Saturday 16 and Sunday 17 July Parisians had the opportunity to see more than 350 of the exquisite miniature items which formed the Princesses' gift. On 18 July *Le Journal* reported: 'an endless procession of admirers had patiently queued to see, at last, the trousseaux,

BELOW: Many little girls were amongst the 30,000 people who saw the exhibition on the second day, but it was noticeable that women – and men – far outnumbered them.

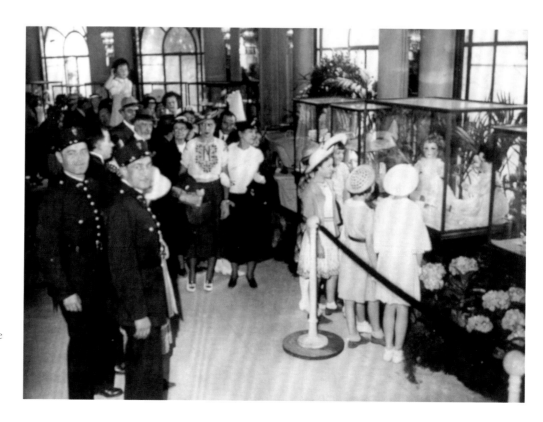

LEFT: The two leather and suede handbags held matching miniature purses, mirrors and compacts. Both Hermès and Pierre Masson made bags; in addition Hermès made gloves for daywear.

possessions and the two "ambassadresses" about which they had read so much during the preceding weeks'. On the Sunday alone, more than thirty thousand people had filed past the glass showcases set up in the foyer of the Marigny Theatre, 'which Monsieur Volterra, obliging as usual, kindly put at the disposal of *Le Journal*. For twelve hours, without the slightest break, from eight in the morning until eight in the evening [they had to extend the hours] a crowd had swarmed into the Champs Elysées to pay tribute to the two ambassadresses . . . while, impassively, the dolls of France watched the crowds go by with wide-open eyes.'

It is interesting that, as the reports acknowledge and the photographs bear witness, 'there were certainly children, especially little girls, amongst the crowds, but grown-ups were the most numerous'. It appeared that men, as well as women, were at least as fascinated by the dolls as the children for whom *Le Journal* had written their special story.

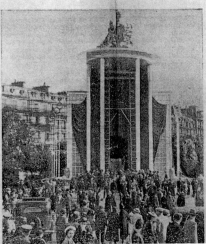

PARIS FERA DEMAIN
une réception enthousiaste aux souverains britanniques

Un appel du Conseil municipal

M. Le Provost de Launay, président du Conseil municipal, vient d'adresser cet appel à la population :

Mes chers concitoyens,

Demain, le roi George VI et la reine Elizabeth seront les hôtes de Paris.

Vous savez le sens, la haute portée de cette visite.

Leurs Majestés, durant leur séjour dans la capitale, sentiront battre le cœur de Paris.

Pavoisez vos fenêtres. Ornez vos maisons. Que les couleurs des deux nations flottent partout entremêlées. Acclamez le roi. Acclamez la reine.

Paris, interprète de la France, dira sa respectueuse affection pour les souverains, sa fidélité à une amitié très chère, sa foi dans l'avenir.

Tous les préparatifs s'achèvent

L'escadre qui accueillera les hôtes de la France à la limite des eaux territoriales a quitté Cherbourg pour se rendre à Boulogne

Une ordonnance de la préfecture de police à l'occasion des cérémonies officielles

DETAILS EN 3ᵉ PAGE 1ᵉʳ COL.

30.000 Parisiens défilent au théâtre Marigny devant France et Marianne

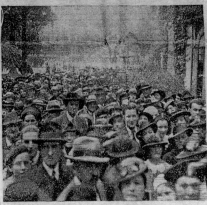

Un aspect de la foule stationnant hier après-midi devant le Théâtre Marigny. — Détails en 3ᵉ page, 5ᵉ colonne.

Le Journal's daily reports on the making of the dolls' trousseaux caught the attention of Parisians of all ages, and vast crowds queued to see their exhibition.

The dolls travel to London

In spite of a strong request that there should be another display of France and Marianne – with all their entrancing possessions – before they left France, it was not possible to arrange a second exhibition and preparations for their journey to England began shortly after the dolls had been accepted by Their Majesties at the Hôtel de Ville on 20 July.

It took Pierre Welter and his team eight days to pack the dolls and all their things. A specially padded travelling-case was made for France and Marianne. The delicate silver monogrammed white satin and kid boxes containing gloves, handkerchiefs and other fragile items had to be provided with covers of stronger fabric before they, and the larger and similarly covered boxes of table-linen and porcelain, could be packed and placed in the twenty crates needed to contain all the items. Bearing in mind that they varied in size and weight – from the tiny boxes containing fragile crystal bottles of perfume to the larger containers for the dolls' big cots,

All the clothes, leather and satin boxes of items, cars, perambulators and cots were packed in padded wooden boxes and crates. The travelling-case for the dolls was not only padded but also lined with a red, white and blue floral fabric

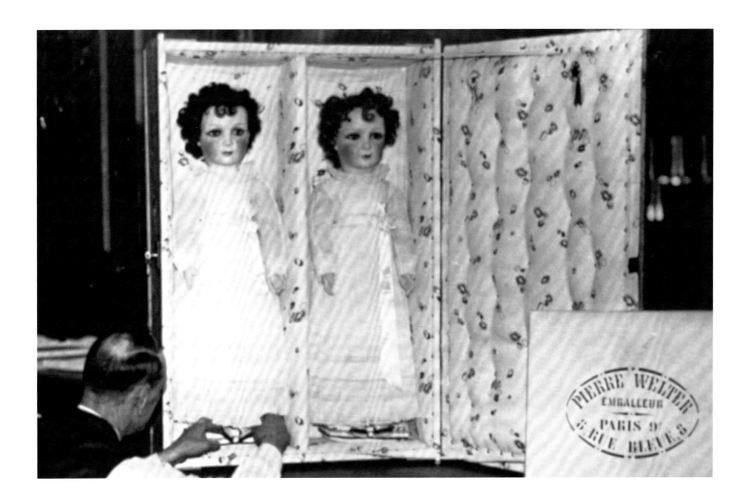

perambulators and cars – it is scarcely surprising that the packing took over a week to accomplish.

The twenty crates were finally fitted into one huge, heavy wooden container that measured 4 x 2 x 2 metres (13ft 1in. x 6ft 6in. x 6ft 6in.). As it also weighed over 2,000 kilos (4,410 pounds), its transport to England by Deloche and Company was no easy task. However, it duly started the journey on 8 August, when it was loaded on to flat wagon number 493-003, its immediate destination being the French Embassy in London.

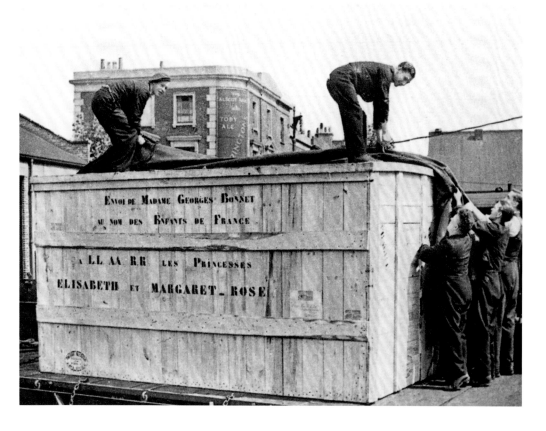

The huge container holding all the boxed items was unloaded at the Bricklayers' Arms goods-yard, near London Bridge station. From there it was taken by road to the French Embassy.

The English press had given the royal gift considerable coverage during the preceding months. Daily newspapers and magazines had carried references to France and Marianne and their unique trousseaux. Fashion magazines in particular had been using drawings as well as photographs to illustrate their articles. The actual transportation of the dolls and their possessions also attracted attention; *The Illustrated London News*, for example, printed several photographs showing the unloading of the container and its journey to London. This magazine had already published illustrations of the dolls 'driving' down the Champs Elysées at the time of the State Visit and four more photographs at the time of their London début.

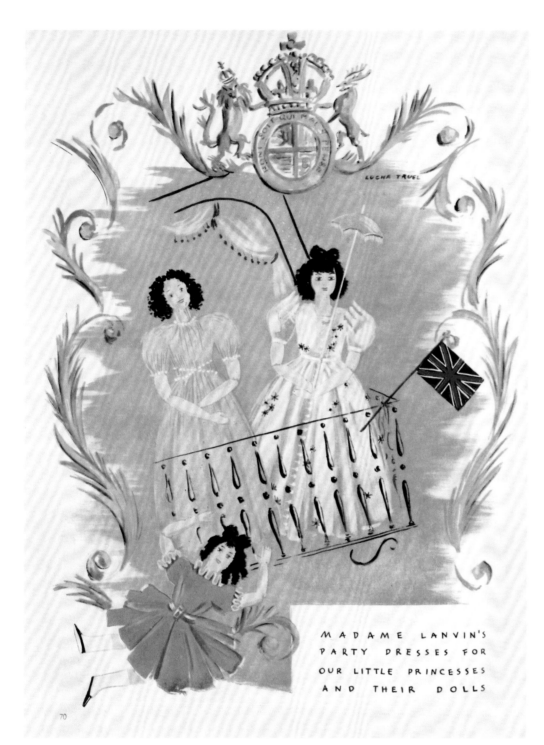

LUCHA TRUEL

MADAME LANVIN'S
PARTY DRESSES FOR
OUR LITTLE PRINCESSES
AND THEIR DOLLS

70

For colour illustrations in 1938, magazines used drawings or paintings. This example, from *Harper's Bazaar*, relies more on artistic ability than authenticity for its attraction.

OVERLEAF: Many magazines, French and English, printed illustrated reports about the dolls' trousseaux for weeks before the presentation of the gift in Paris. This page, from the *Weekly Illustrated* magazine, is a typical example.

As printed photographs in 1938 were black and white, the clothes' full beauty was not revealed. The dress held by the model on the *Weekly Illustrated* page is here worn by France.

FINEST EVER : The most magnificent dolls' clothes ever made will adorn the dolls presented to Princess Elizabeth and Princess Margaret Rose. Above, an evening dress made by Rochas.

FAMOUS DESIGNERS DRESS DOLLS FOR THE PRINCESSES

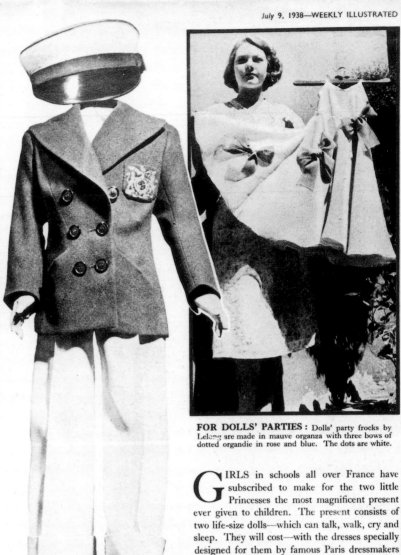

SEAFARING DOLLS: Smart sailor-suits for both the dolls have been made by the firm of Patou; below, making the dresses has been fun for the work-room staff.

FOR DOLLS' PARTIES : Dolls' party frocks by Lelong are made in mauve organza with three bows of dotted organdie in rose and blue. The dots are white.

GIRLS in schools all over France have subscribed to make for the two little Princesses the most magnificent present ever given to children. The present consists of two life-size dolls—which can talk, walk, cry and sleep. They will cost—with the dresses specially designed for them by famous Paris dressmakers—about £10,000 for the pair. The dolls are called France and Marianne, and they will be presented during the course of the Royal visit. Exclusive pictures of the dolls' clothes were specially taken for " Weekly Illustrated " in Paris.

RIVER FROCK : Dolls will be able to idle through Boulter's Lock in charming summer dresses with sprays of flowers and tiny coatees with hats to match—by Patou.

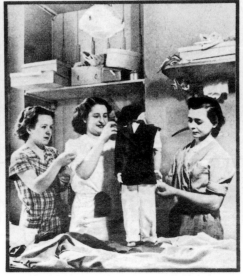

SHOES BY FAMOUS MAKER : Hellsten, famous Paris shoe-maker, made these and a dozen other pairs of dolls' shoes. Gloves were copied from a model by Alexandrine.

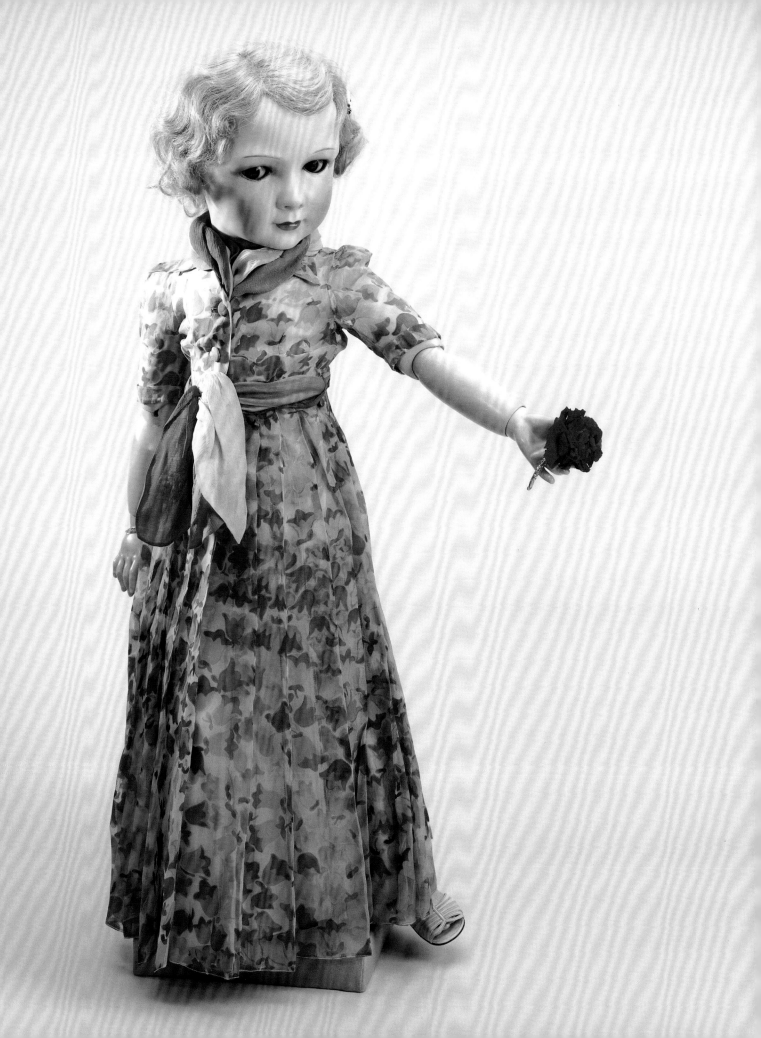

Pathé Gazette Company was allowed to film the St James's Palace exhibition before it opened. The sequence made for the weekly newsreel programme concentrated on close-ups of the dolls after a few long shots of the display.

Even *The Times* devoted several columns to their reviews of the dolls' trousseaux and covered their exhibitions in both capitals.

That the diplomatic importance of the dolls was recognised in 1938, on both sides of the English Channel, is illustrated by their inclusion in the various newsreels which were popular features of all cinema programmes. One of these, produced by Pathé Pictures Limited for their Pathé Gazette newsreel in December, opened with a feature about children being fitted with gas masks. (This might seem surprising, as war was not declared until September 1939, but it demonstrates the tension building up in 'crisis year'.) The second item on their programme was about the royal dolls, France and Marianne, and included a filmed preview of some of the items displayed in the dolls' exhibition at St James's Palace.

The last 'duty' performed by France and Marianne in Paris was their exhibition, entrance fees for which had been donated to charity. The first time they were seen in public in London was also of benefit to charity, so their roles as 'ambassadresses' were not forgotten after they crossed the Channel to become the Princesses' wonderful gift.

Although the dolls had arrived at the French Embassy in London during August, it was not until 15 November that *The Times* was able to report that Monsieur Charles Corbin, the French ambassador, had been received by Queen Elizabeth at Buckingham Palace the previous evening, and had personally delivered to the two Princesses their by now internationally famous dolls and trousseaux. As Princess Elizabeth wrote to her grandmother, Queen Mary: 'Monsieur Corbin came yesterday to hand over the dolls on behalf of the French people and we showed him all the clothes.'

The following week the Princess wrote in French to Georgina Guerin, the daughter of Madame Madé Guerin, who had been governess to Lady Elizabeth Bowes-Lyon (later Queen Elizabeth) and her sisters. Georgina Guerin tutored Princess Elizabeth and Princess Margaret Rose in conversational French and would have had a particular interest in the gift. The letter reads (in translation):

We saw the dolls on the Wednesday after you left. They really are pretty. They are nearly as tall as Margaret and the dresses! Oh! It is almost impossible to say. There are long dresses for evening – one is covered in little frills . . . All the dresses are different and Marianne has a leopard-skin coat . . . The dolls have two beds, two perambulators and two little cars. They are going to be put on public display soon and the money will be given to French children in hospital, I think.

Forgive me for not replying to your letter sooner but we are so busy now. You must see the dolls.

On 15 November *The Times* announced also:

that the children of this country may have the opportunity of seeing the gifts, it has been decided that the dolls with their wardrobes shall be exhibited at St James's Palace from December 10th to December 24th. A small charge will be made and the proceeds will be devoted to charities . . . so extensive are the wardrobes and accessories that it will require the whole of one of the State Rooms at St James's to accommodate them.

When the idea of a London exhibition was discussed, it was recorded that Her Majesty gave her gracious permission for the display to be held at St James's Palace. Bearing in mind that all foreign ambassadors to this day first present their credentials at the Court of St James, one cannot help wondering if the organisers appreciated just how appropriate it was that 'the two ambassadresses', France and Marianne, should make their first appearance in England at that historic palace.

Three days before the exhibition opened, full details of times and charges were given and the English charity that would share the proceeds with its French counterpart was named: the Princess Elizabeth of York Hospital for Children. Many English newspapers mentioned the exhibition and the favourite illustration for their reports showed the dolls in two of their most elegant long dresses. Previously their most published photograph had been a far more carefree one, showing them 'driving' their Citroën cars down the Champs Elysées, past two rather bemused little girls.

In Paris, *Le Journal* had not forgotten its protégées. On 10 December it printed another letter:

Dear little children of France. You might be a little angry with us for not having given any news for several weeks about your two great friends, France and Marianne, the dolls of the English Princesses . . . like some of you they hate writing and have not sent their latest news.

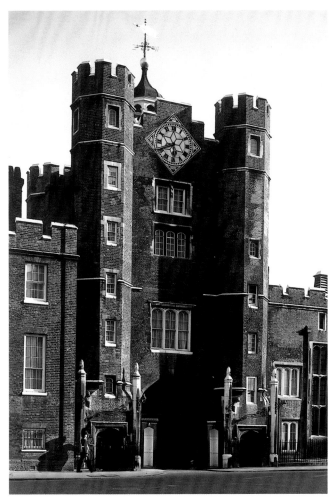

St James's Palace, London. The Court of St James, to which all ambassadors are appointed, was the fitting first venue in England for 'ambassadresses' France and Marianne. In December 1938 their exhibition filled one of the state rooms.

THE LITTLE PRINCESSES GO TO SEE THEIR OWN DOLLS ON EXHIBITION.

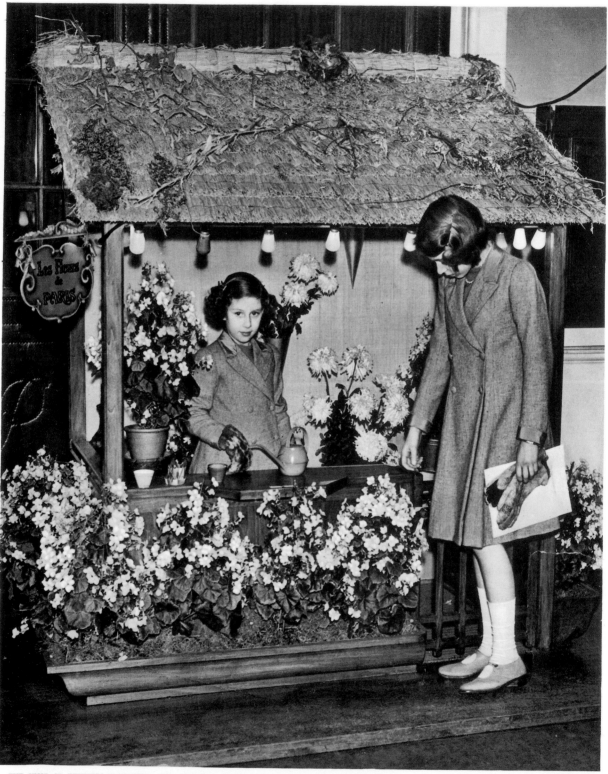

THE VISIT OF PRINCESS ELIZABETH AND PRINCESS MARGARET ROSE TO THE EXHIBITION OF THE DOLLS PRESENTED TO THEM BY THE CHILDREN OF FRANCE, HELD AT ST. JAMES'S PALACE : T.R.H. AT THE FLOWER-STALL MADE FOR THE DOLLS, "FRANCE" AND "MARIANNE."

Before leaving for Sandringham Princesses Elizabeth and Margaret Rose called at St. James's Palace for a thorough inspection of the dolls presented to them by the children of France, which are being exhibited there. They were very much entertained, for they had not seen these gifts fully laid out before ; and they found many surprises. The two dolls, "France" and "Marianne," in addition to being well provided for every occasion of a doll's life, have their own flower-shop, at which the Princesses are seen in this photograph. The St. James's Palace Exhibition, held in aid of the Princess Elizabeth Hospital for Children and also a French charity, was originally timed to close on Christmas 'Eve, but owing to its great popularity it opened again on Boxing Day for an indefinite period. Before the intense cold the attendance averaged 1600 visitors a day, and when the schools closed it was hoped to reach this total again. (I.N.A.)

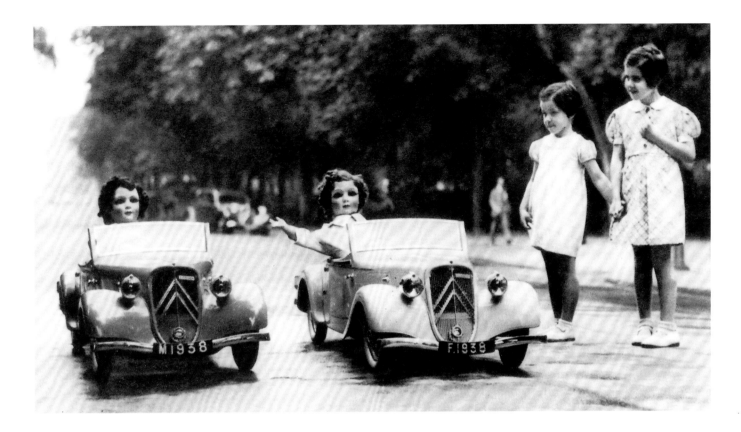

And as Princess Elizabeth and Princess Margaret Rose are very studious, the King and Queen, their father and mother, did not want them to be distracted from their lessons by giving them our Parisian dolls in the middle of term, so they waited until nearer Christmas . . . However, the dolls' godmother, Madame Georges Bonnet, has just received a letter from the French ambassador in London, Monsieur Corbin . . . here is his missive . . .

Driving along the Champs Elysées . . . the photograph that most picture editors chose. It was the first to focus on the dolls with two of their possessions, rather than their trousseaux of clothes.

That letter described the ambassador's visit to Buckingham Palace to give the Princesses their dolls.

Two days later a report described the display, mentioning the two 20-metre (66 ft) tables of trousseaux items, the cots, perambulators and cars to one side of the state room and Princess Margaret's flower shop on the other. An *Illustrated London News* photograph, taken at St James's Palace during the Princesses' visit to the exhibition, shows the owner standing inside the thatched Wendy-House-type flower stall. Her 'customer', Princess Elizabeth, is outside the open-fronted wooden shop, seemingly making her choice from the masses of flowers on display. The Princesses were taken by their governess to see their dolls on 22 December, on their way to spend Christmas at Sandringham in Norfolk.

OPPOSITE: Lachaume's flower shop was created specially for Princess Margaret Rose so that the younger Princess might have a real plaything. Although not one of the dolls' possessions, it was included in the display as part of the whole royal gift.

The cover of the exhibition
catalogue was drawn by
Rex Whistler's cousin, Hector
Whistler. He also produced the
line drawings of the dolls that
were printed and sold as
postcard souvenirs.

MARIANNE

Both *Paris Soir* and *La Croix* carried photographs of 'the ambassadresses' and mentioned the exhibition on 10 December, the day after it opened.

Queen Mary, the Princesses' paternal grandmother, was one of the patrons of the children's hospital in Shadwell – which had been named after Princess Elizabeth when its old name, the East London Hospital for Children, had been changed in 1932. At that time Princess Elizabeth's parents, King George VI and Queen Elizabeth, were the Duke and Duchess of York and the Duchess had laid the foundation stone of a new branch for convalescent children, at Banstead in Surrey.

In 1938 the redeveloped hospital was in urgent need of funds to complete the building and its royal patrons once again provided practical assistance. It had been Queen Mary's idea that Princess Elizabeth, like her mother and grandmother, should become actively involved with the hospital which bore her name, and the young Princess was made a junior patron. Both she and Princess Margaret made items which were sold at charity bazaars at which the junior league of helpers assisted. Because of their involvement, it was decided that proceeds from the dolls' exhibition should be donated to the Princess Elizabeth of York Hospital for Children.

Miss A. Coulton, the matron, and Brigadier General Sir Hill Child, the hospital's chairman, accompanied the Princesses when they visited the exhibition. It had been due to close on Christmas Eve but such was its popularity that it reopened after the festival and continued until 14 January 1939.

A simple six-page catalogue was produced which listed all the exhibits and credited their makers, and the foreword and inside cover pages gave some information about the hospital and its patrons (see pages 123–30). It was sold to benefit the appeal fund. The black-and-white cover illustration, a freestyle drawing incorporating France, Marianne and symbolic French and English emblems, was the work of Hector Whistler, cousin of the more famous artist Rex Whistler. Hector Whistler, born in Jersey in 1905, studied architecture there before joining the army in the mid 1920s. From 1936 to 1938 he studied art at the Slade, and he joined the Royal Air Force in 1939. After the war he travelled extensively, especially in Jamaica and the United States, where his work was widely exhibited. He died in 1976. As well as designing the cover, Hector Whistler drew 'portraits' of the dolls in the dresses they wore in the exhibition. These drawings, more formal in style than those on the catalogue's cover, were reproduced later as picture postcards.

The remarkable quality of the dolls' trousseaux caught the attention of those who saw the exhibits. Despite the bitterly cold weather that mid December, it was estimated that some 1,600 people a day paid to see the display. Many were

OVERLEAF: Two photographs found in the archives of the Princess Elizabeth of York Hospital for Children. The matron, Miss Coulton, appears with the Princesses in one, but it seems that neither picture was used by the press.

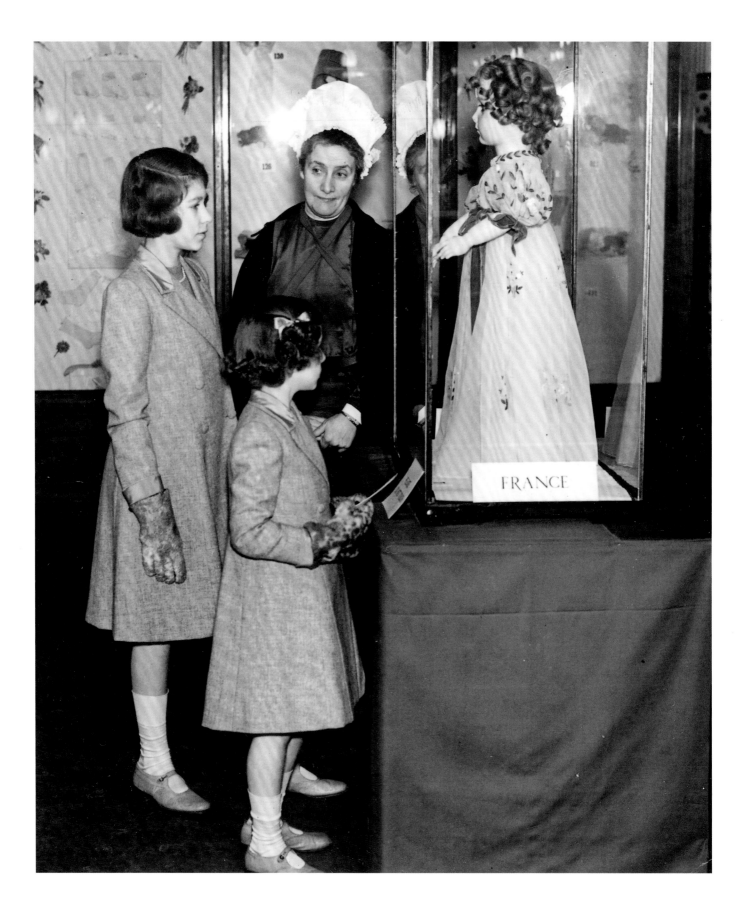

FRANCE

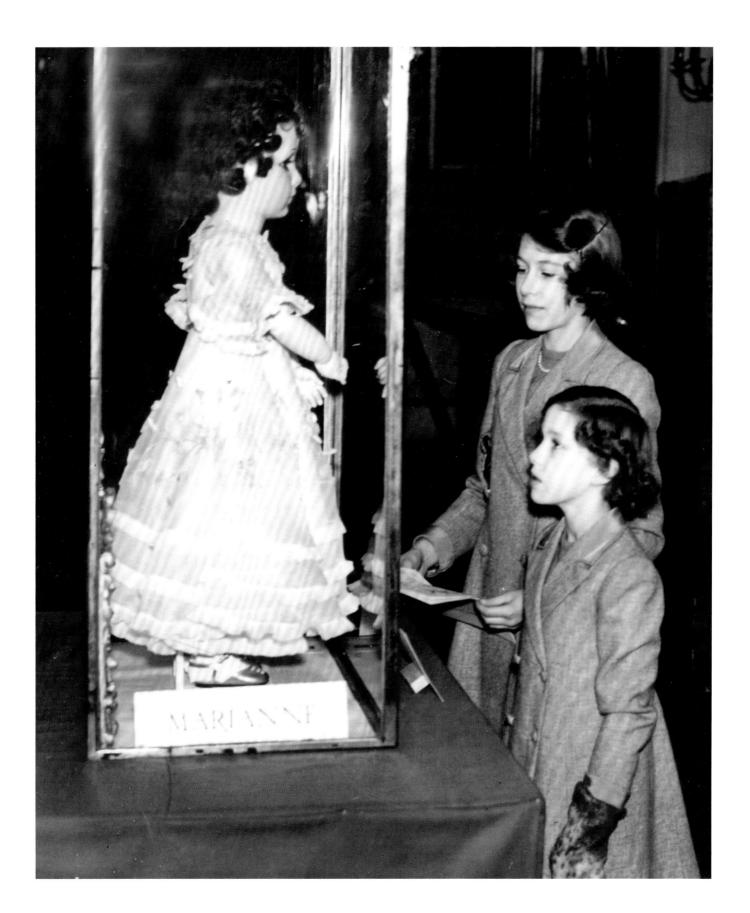

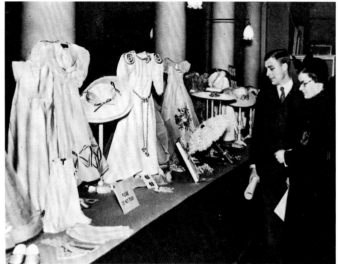
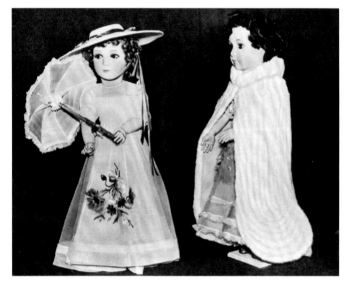

The *Illustrated London News* featured
the exhibition more than once.
One of their illustrations (right)
on 17 December showed the dolls
in their best-known ensembles;
Marianne's ermine cloak was the
garment most frequently mentioned
in press reports.

attracted by the reports in the popular press. Marianne's picture, which appeared
in several newspapers, showed her wearing an ermine cloak valued at that time at
200 guineas (£210). It was just one of the many items in the 'costliest wardrobe
in the doll world', as one reporter enthused. As several newspapers pointed out,
it took the whole of one of the state rooms at St James's Palace to display all the
items in the dolls' trousseaux. None of the newspapers seemed to have been
tempted to follow *Le Journal*'s example and present France and Marianne as
'living dolls', but all paid tribute to 'the traditional French taste, workmanship
and artistry which have been exploited fully to make this gift a thing of beauty'.

France and Marianne: fact and fiction

Any original touches of fantasy in the dolls' story were included purely to please the children who eagerly read the daily reports about them. The strange myths about the dolls that developed later are less easily explained.

Almost from the beginning minor discrepancies about the dolls appeared in newspapers and magazines. Their height varied, France (or Marianne) was sometimes described as the brunette with brown (or blue) eyes, some reports stated their trousseaux were packed 'in a dozen blue leather cases' and so on. Even *Le Journal* was guilty of confusing the dolls' identity on at least one occasion; the report on 24 June described Marianne's blonde hair as having a parting on the right side, but Marianne is the brunette. It is France who has blonde hair.

Later, more serious errors were made. Successive writers, with more imagination than accuracy, reported that France and Marianne had 'flexible hands', mechanical hearts 'that beat to represent the heart of France', and voice-boxes that allowed them to speak. All these statements are completely untrue. At this time, several firms did indeed make dolls that had special features such as 'heart-beats' and voice mechanisms, but none of these novelties was deemed necessary or fitting for France and Marianne.

For the record, the dolls are 86.2 cm (2 ft 10 in.) tall and have identical bisque heads and jointed bodies, their individuality being achieved by differences in eye and hair colouring. The mark on the back of their torsos is:

JUMEAU
PARIS

and on the back of their necks:

149.

France is the brown-eyed blonde and Marianne the blue-eyed brunette. Before their presentation each doll had been fitted 'with a gold chain bracelet which incorporated their name plaque encrusted in enamel in the French colours. This was a gift, both practical and precious, from Monsieur Roger Weger' – one that certainly settles any confusion about identity.

Their marks: the number 149 was incised on the back of both dolls' necks.

Although the names of the dolls have sometimes been confused, close examination of their delicate little bracelets removes all doubt.

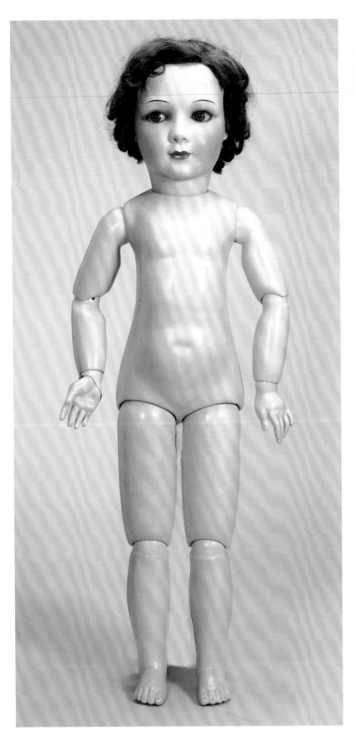
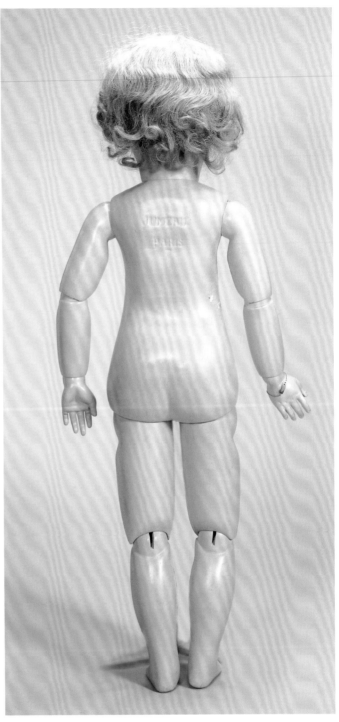

Marianne and France posed to show the construction of the two dolls. Their ability to hold any position is regulated by the tension of the elastic cording threaded through the limbs and torso. The height of each doll is 86.2 cm (2 ft 10 in.).

The foremost French doll-making firm of Jumeau had been famous since the 1840s for the quality of its many lines of beautifully costumed dolls. Although the family firm ceased trading as such in 1899, many Jumeau workers continued to make Jumeau dolls for the newly formed SFBJ (Société Française de Fabrication des Bébés et Jouets).

France and Marianne were Jumeau dolls – and it is ironic that three of the most beautiful attributes of the firm's renowned dolls were missing from the two chosen to be the royal gifts. The Jumeau dolls' lovely 'paperweight' glass eyes, one of their main attractions, were thought to be not quite right for France and Marianne; and Monsieur Peigne, a highly skilled maker of artificial eyes for human patients, was consulted. He made similar, but bigger, eyes specially for these two dolls, using the finest enamels and crystal glass for his unique commission.

The second missing attribute was Jumeau wigs. France and Marianne's wigs were made instead by the coiffeur Valentin, who also usually had human clients. The method employed was the same as for women's wigs, but for dolls the construction was far less complicated. The wigs supplied by Jumeau for their more expensive dolls were elaborately curled and often made from real hair. It was thought, though, that the royal dolls should have the very finest quality available, and the blonde and brunette styles chosen for France and Marianne were custom made.

The clothes and accessories Jumeau provided for their dolls were equally famous. Beautifully made, fashionably styled outfits for child and adult female dolls helped to create their 'special' quality and popularity in the luxury range. In the case of France and Marianne this third attribute was missing, and it is perhaps a little sad that they left the factory without even a chemise to add to their amazing trousseaux.

Given the prestige of Jumeau dolls, it is hardly surprising that they were chosen for the royal gift; but the choice of two plump 'little girl' dolls to be the mannequins displaying Parisian haute couture in preference to any of the firm's slim, adult-looking fashion dolls is not so obvious. Generally speaking, the Parisian press concentrated on France and Marianne in their role of promoters of French haute couture, or on their creation as a symbolic offering, but *Le Journal* never forgot a third important aspect: their effect on children. If the sponsors of the project chose exquisite miniature models, elegant and 'grown-up', would they really appeal to the children in whose name they were being given? And what would be the reaction of the two young English Princesses who were to receive them? Princess Elizabeth, aged 12, might appreciate the beauty of such dolls, but Princess Margaret, being four years younger, was more likely to regard dolls as playthings. What kind of doll

OVERLEAF: The eyes for France and Marianne were specially made by an expert artificial eye maker. Additional naturalness was achieved by the mechanism holding them in place as it allows sideways and up-and-down movement and also for the eyelids to cover the eyes when the dolls lie down to 'sleep'.

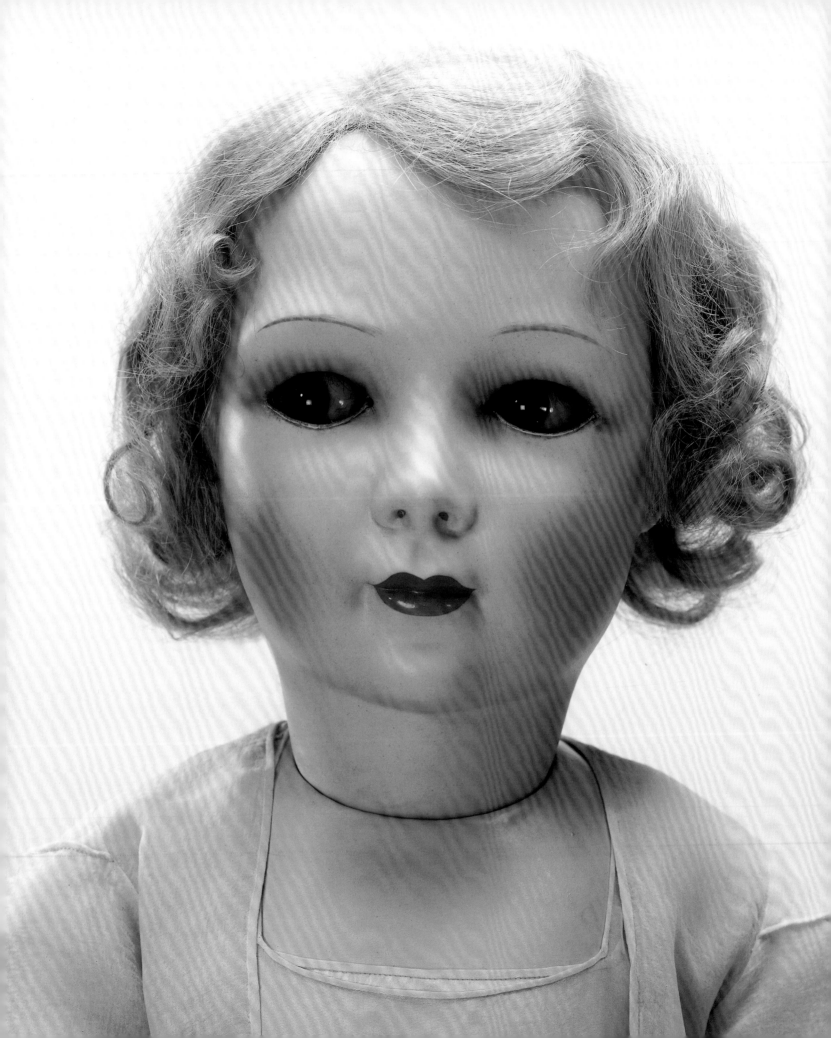

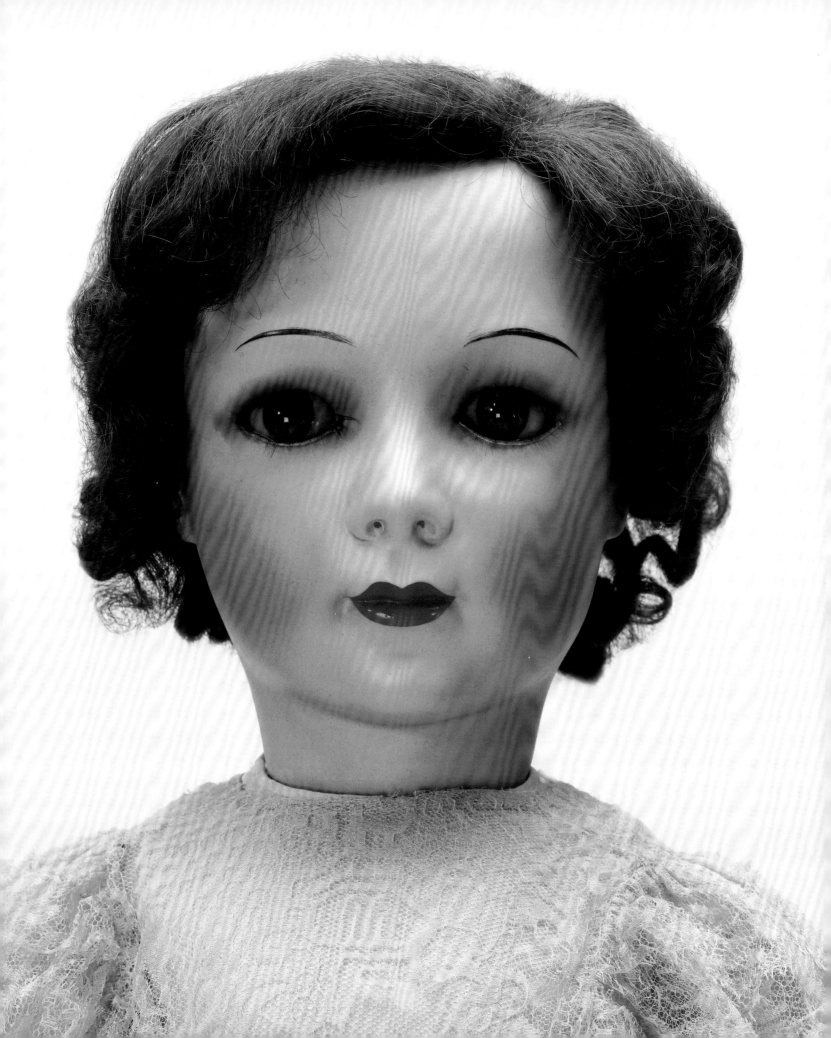

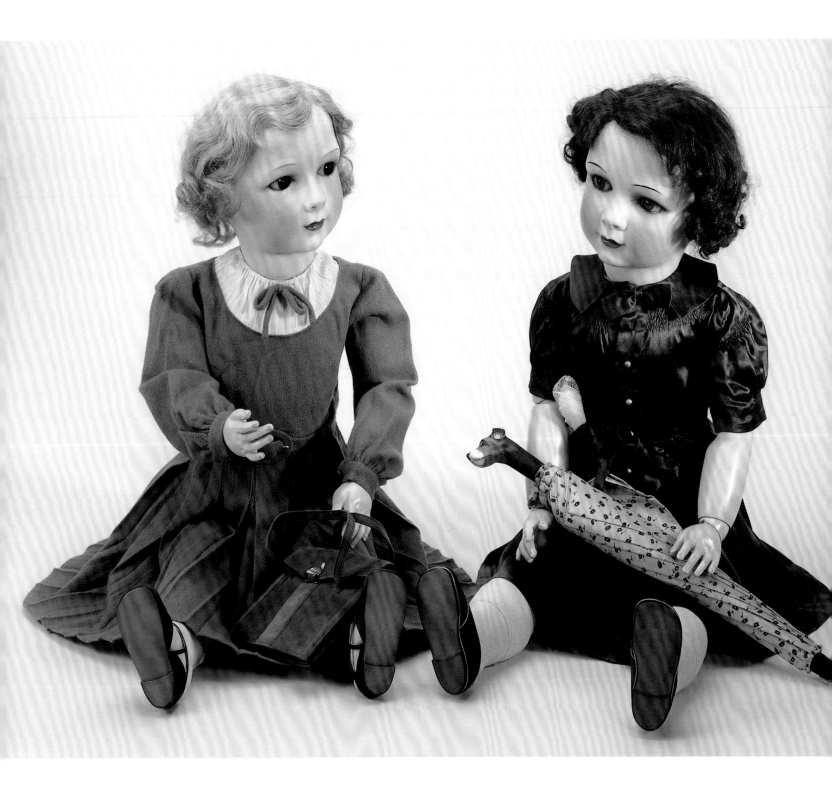

Two juvenile dresses, less glamorous but as meticulously made as their adult ensembles. France wears a Robert Piguet blue woollen 'school dress' and Marianne, holding her Henri à la Pensée umbrella, is in 'a brown satin morning dress' by Paquin.

would be most likely to engage the interest of the French children and please both the Princesses?

One can only speculate about the reason for the choice that was made, but it was perhaps decided that, as all little girls were felt to love dressing up in their mothers' clothes, children would relate best to two 'little girl' dolls with trousseaux of exquisite clothes designed for an older age group. If, in addition, some of the garments were to be made as fashionable outfits suitable for children's wear, the Princesses could choose whether their dolls were to be dressed as 'ambassadresses of fashion' or 'little girls', the two roles created for France and Marianne by *Le Journal*. Certainly the dolls looked equally charming in their juvenile outfits and in their elegant furs and evening dresses – which is a great tribute to the skill of the couturiers.

To be required to turn two young, rather rotund, clients into svelte and sophisticated fashionable ladies must be every designer's nightmare. France and Marianne lack any definable waist or bust, so the dolls did present their couturiers with a serious problem. None the less, they succeeded brilliantly in creating trousseaux of charming garden-party ensembles and ballgowns, chic day dresses and sportswear, their skill as designers being matched by the expertise of their seamstresses and embroiderers.

It is almost impossible not to echo the 'Courrier des Poupées' report of 23 June 1938: 'How can we do justice to everyone? If we praise one we're in danger of offending the others.' Despite this feeling, perhaps half a dozen garments could be mentioned for, in addition to illustrating the superb quality of all the items in the collection, they are individually of particular interest.

The gown worn by Marianne at the exhibition in St James's Palace was designed by Lucile Paray especially for this doll. It must have tested the skill of the embroiderer to the utmost, for the intricate golden corn design which decorated this ivory silk organza evening dress was created by couching lengths of real straw, a notoriously difficult material as it easily split or broke when being twisted into the required pattern.

One of Jean Patou's ensembles, worn by France in the display case at Windsor Castle, is a white organdie garden-party dress, with another exquisite embroidered design. Patou's inspiration also came from the French countryside; for silk embroidered sprays of red poppies, white marguerite daisies and blue cornflowers tied with twists of cornstalks embellished the skirt. The colourful and beautifully worked flowers are themselves eye catching; but equally noteworthy, though less obvious, is the inspiration for the design. It had long been a rural French custom

to present visitors with a posy of wild flowers in the country's national colours, red, white and blue. This designer echoed the charming tradition in the embroidery design created for the dress and the broad-brimmed white Panama hat, with its long, similarly coloured ribbons worn by France.

Paquin, Weil, Max and Jungmann all made superb fur coats for the dolls. Max's elegant, long white ermine evening cloak, with an embroidered lining of white georgette, is worn by Marianne at Windsor and is a beautiful example of the furrier's skill. Perhaps even more interesting is the model made by Jungmann. This coat, of grey Indian lamb, is trimmed with crimson velvet on the collar and cuffs and was one of two designed to be worn by the dolls when dressed *à la jeune fille*. A small, matching fur muff was an addition that would have delighted any little girl and the outfit was completed by the crimson velvet bonnet from Jane Blanchot.

Charmis created several beautifully embroidered nightdresses and negligées – one, a peach satin and chiffon set, being amongst the finest examples of needlework in the trousseaux. All the lingerie and nightclothes are truly exquisite. The scale of the garments and the satin and chiffon materials used mean that the tiny, meticulous stitches needed to make the items and their embroidered details must attract the respectful admiration of any needlewoman.

Though some of the couturiers chose to present miniature versions of ensembles which would form part of their next season's fashion shows, others – like Jean Patou's very chic yachting outfit – were designed for the dolls. This was the only design to incorporate trousers, but the trousers – combined with a well-cut blue blazer and dashing white cap with a black peak – look entirely suitable for a royal doll to wear for Cowes or some similar occasion.

Both dolls had the same number of clothes, many being paired in the sense that their design was duplicated though the colours varied – as in the pale-blue and white velvet house-coats that were supplied by Suzanne Joly. However, there were some exceptions, notably the lime-green satin *robe de chambre*.

Although one of the original ideas seems to have favoured a white, pale to deep-pink and blue theme for all the outfits, later it was felt that such a colour scheme would be too restrictive. The dolls' trousseaux eventually incorporated emerald green, petunia, brown and navy-blue coats and dresses; and bright-blue and yellow bathing-suits among their juvenile clothes. The designers also added green, violet, yellow, gold, silver, multi-coloured plaids and many deep shades of red and blue to the pastel colours first planned for their adult ensembles. Only their lingerie and nightclothes were made in pale shades of peach, pink, blue and ivory.

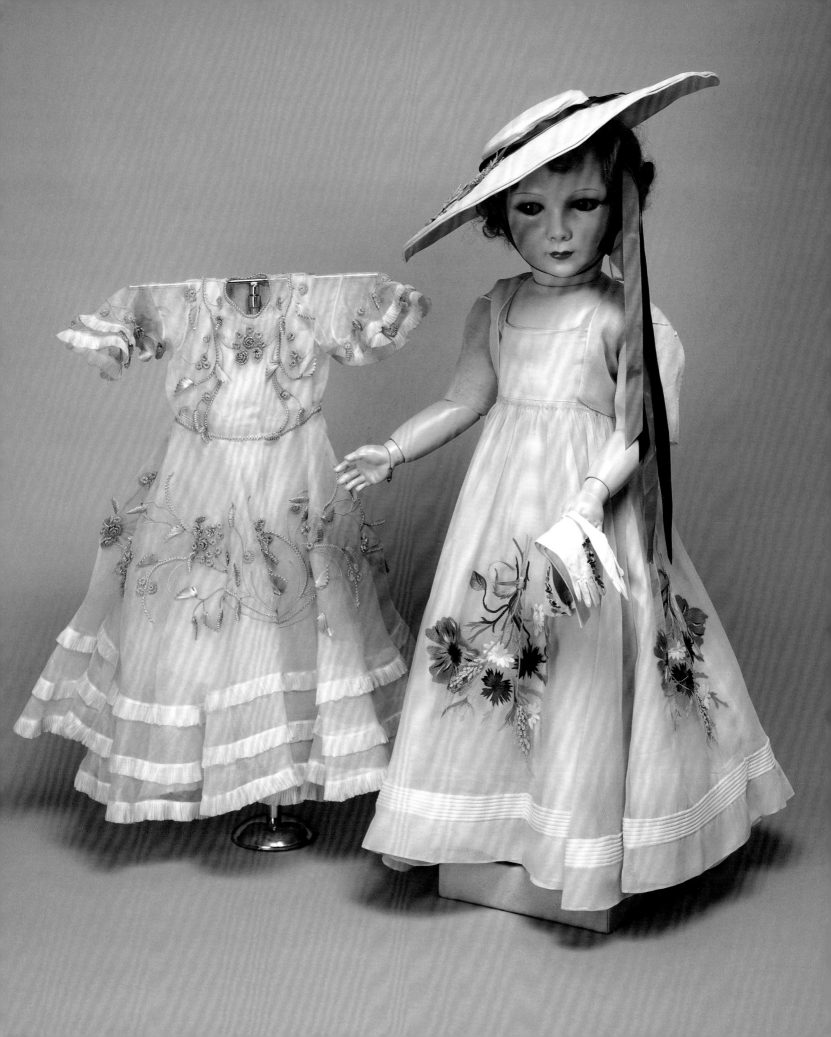

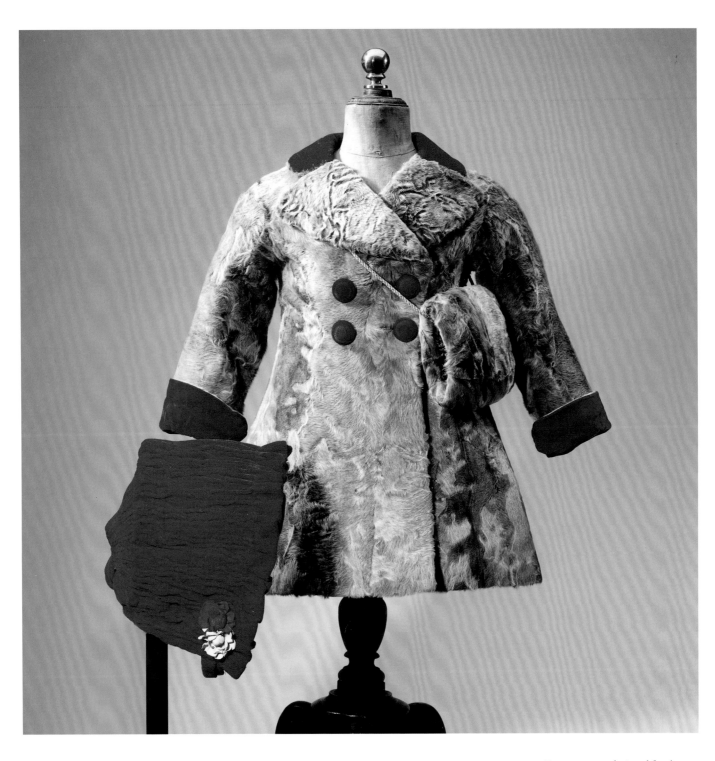

Fur coats were designed for the dolls in juvenile as well as adult mode. This grey Indian lamb coat and muff, trimmed with crimson velvet, are by Jungmann and the matching velvet bonnet was made by Jane Blanchot.

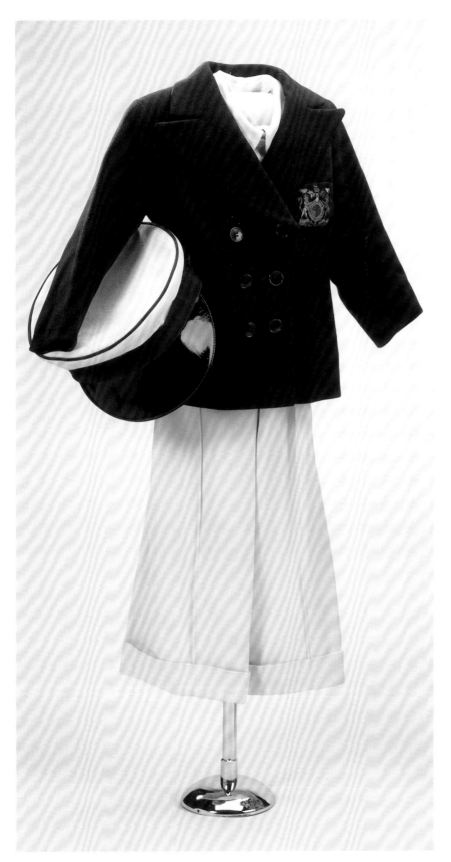

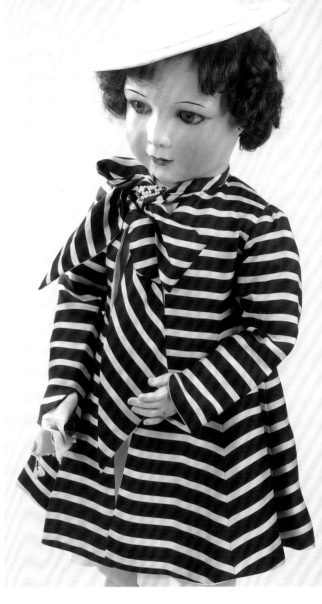

The only couturier to design an ensemble that included trousers was Jean Patou. This chic yachting outfit had a white linen shirt and trousers, blue blazer and peaked cap. Another navy-blue and white design was the dress, hat and coat, designed by Lucile Paray for a more formal occasion.

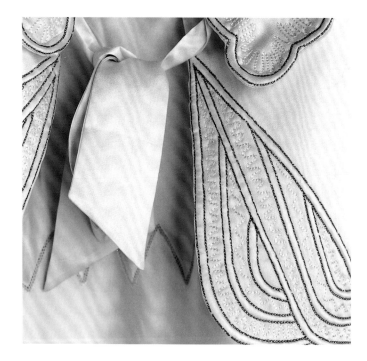

RIGHT: The fine quality of all the material used for the lingerie is matched by the seamstresses' skill in making such delicate garments. Charmis created several sets for the dolls, including this exquisitely embroidered chiffon and satin nightdress and negligée.

Even for expert needlewomen, the intricate decorative detail of the dolls' lingerie was a challenge. The reduced scale of the garments magnified every stitch and tiny, regular lines of stitches were needed for the embroidered and quilted pattern of Chalom's matinée coatee's collar.

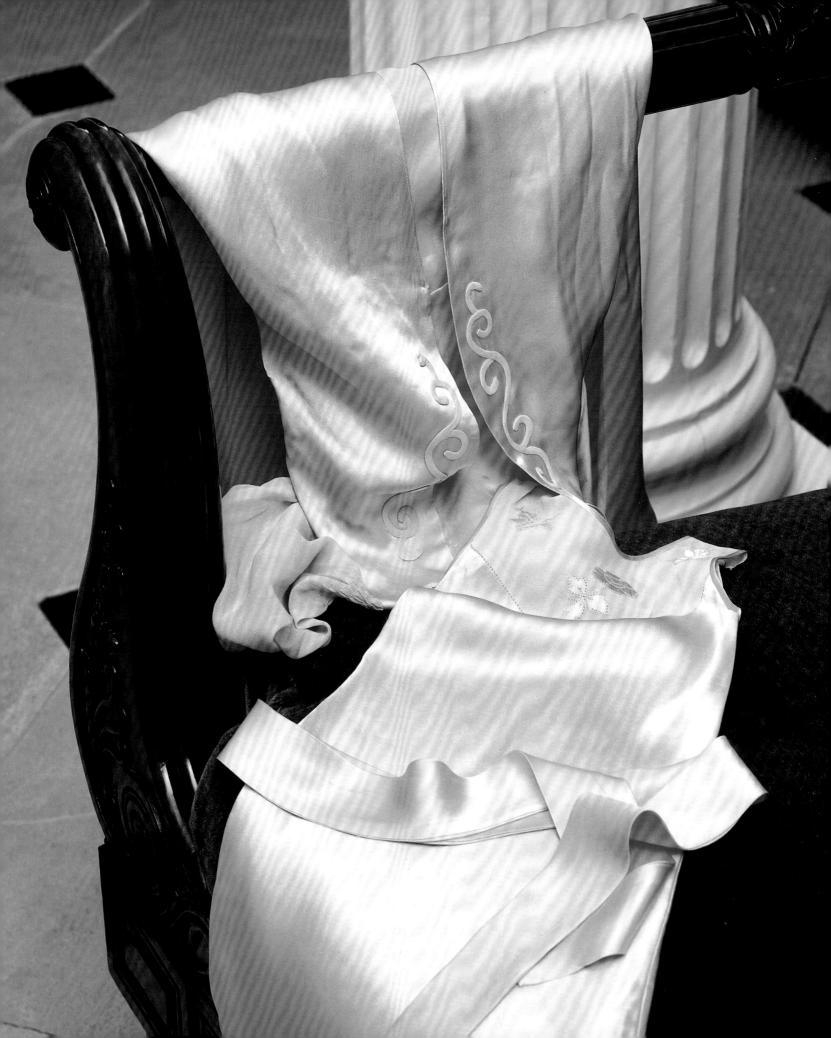

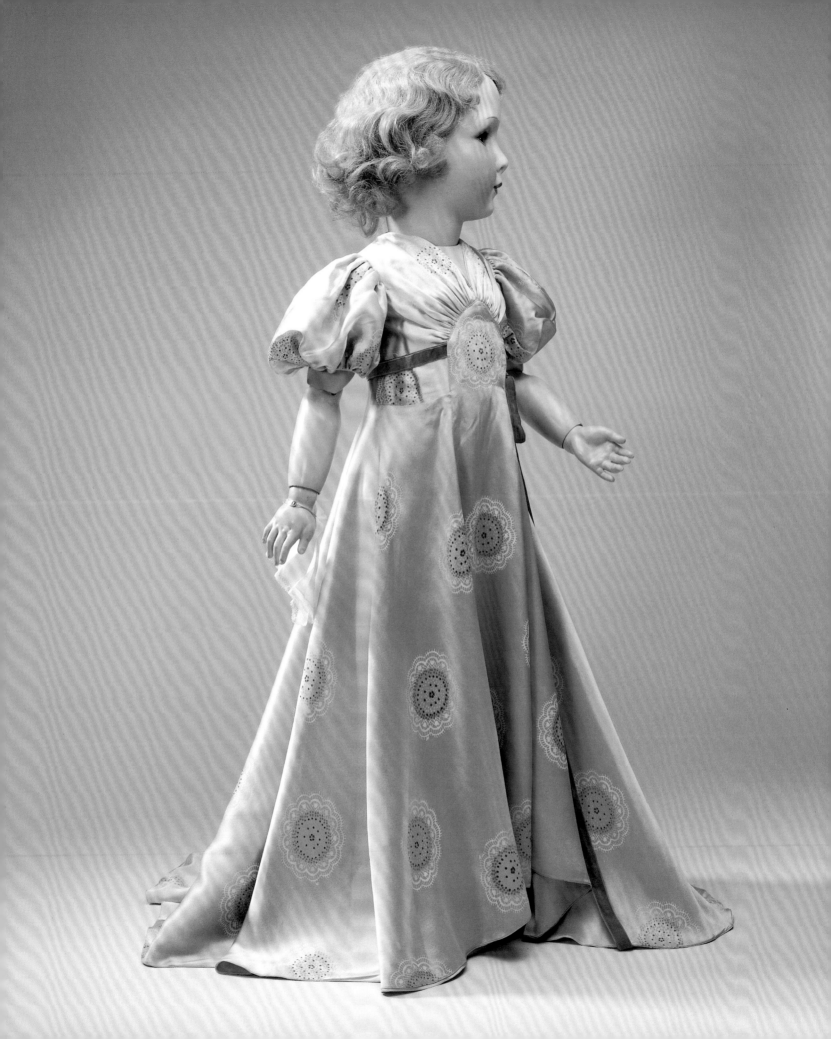

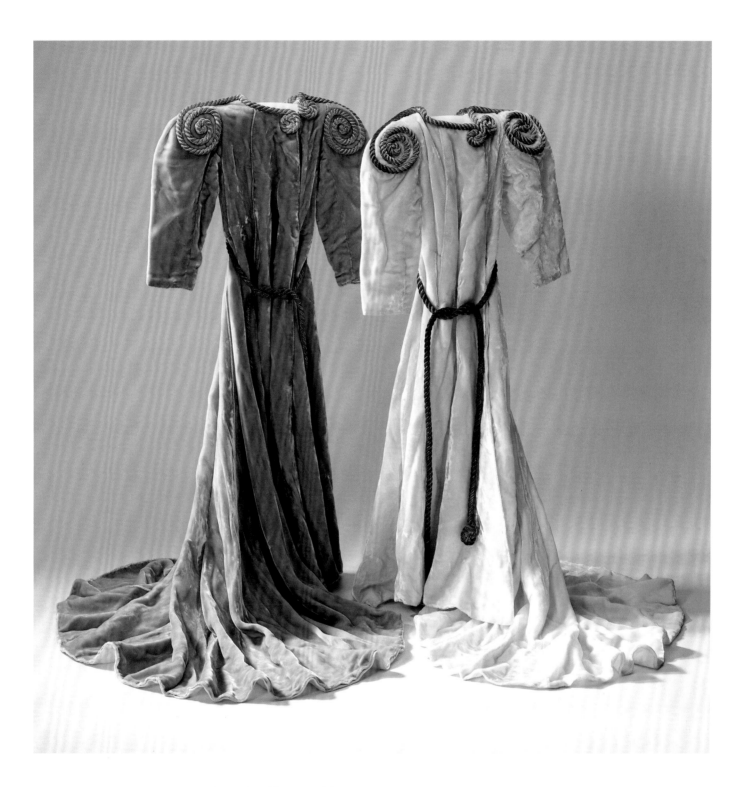

OPPOSITE: France, wearing an elaborately cut satin negligée by Charmis.

ABOVE: Two of Suzanne Joly's dramatic velvet house-coats trimmed with metallic cording.

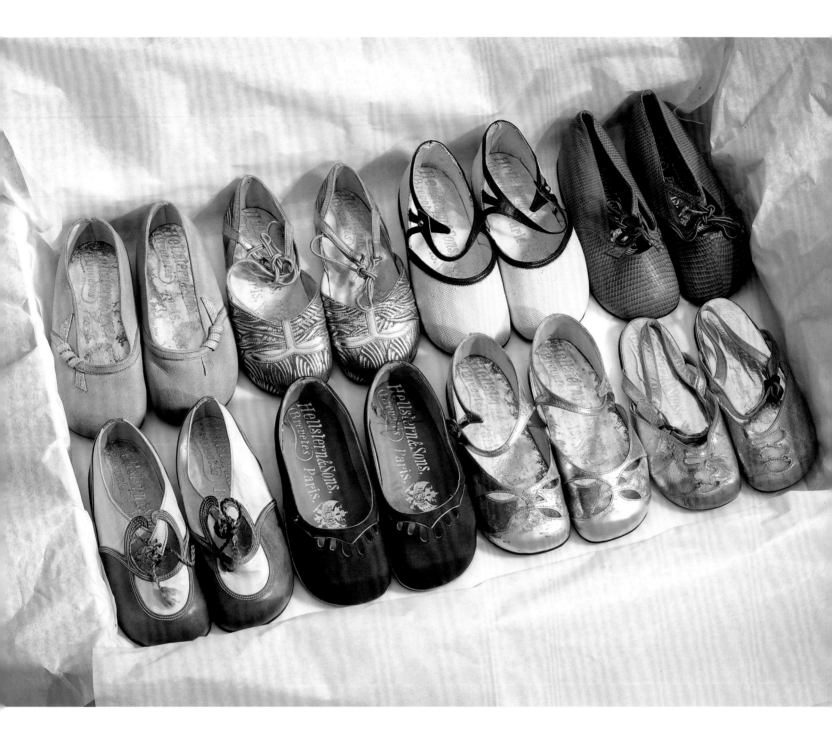

Eight pairs of the many shoes
Hellstern designed to match the
dolls' day and evening outfits.

The difficulties all the designers had experienced when creating adult clothes for the dolls had been due to their clients' childish figures. This problem was shared by the designer of the dolls' shoes. France and Marianne had been given very rigid feet, without any ankle joints and with completely flat soles. Sensible though the design was (to enable the dolls to hold a standing pose), it did make things difficult when creating footwear.

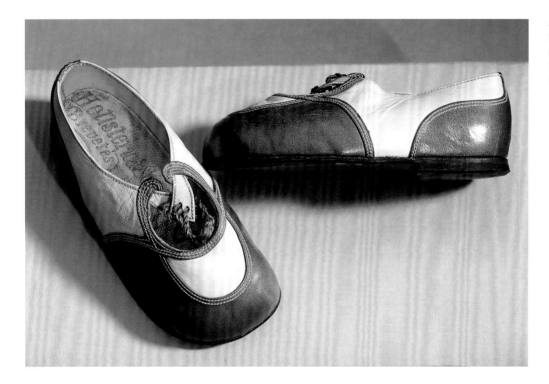

As France and Marianne had rigid flat feet the shoe designers could only create the illusion of heels, which would have upset the dolls' balance.

However, they had to have shoes for all occasions – to look appropriate when worn with sophisticated, adult ensembles – as well as their childish sandals and slippers. Hellstern designed and made all the beautifully crafted shoes, every pair looking extremely effective due to clever cutting and styling that disguises the lack of heels which normally would have been an important part of adult shoes. Given the rigidity of the dolls' feet, it is perhaps ironic that the makers of their shoes were famed for the ballet shoes they supplied to dancers at L'Opéra Comique.

Perhaps rather surprisingly, the dolls were not provided with any silk stockings, only an assortment of pink and white knitted silk socks of various lengths.

Probably the accessories which received the most attention at the exhibitions were the exquisite dolls' gloves, presented in long, white satin or kid-covered glove-boxes adorned with a silver monogram, F or M. Many of the kid and fabric gloves had

Bonneterie had supplied the dolls with pink and white socks of every kind, plain and patterned in ankle, calf and knee length.

been specially dyed to match the dolls' outfits, and those that were embroidered echoed the decoration on their dresses. Perrin and Alexandrine made more than fifty pairs, the gloves being both wrist length for daywear and long for garden-party and evening wear.

In addition to all the hats, parasols, fans, jewellery and handkerchiefs that completed their trousseaux, the dolls were provided with an assortment of wonderful possessions. All their perfect little handbags and sewing-boxes were filled with miniature mirrors, compacts and purses, tiny scissors and gold thimbles. Maquet's two writing-cases, of blue and pink leather, were embossed with the dolls' crowned monograms and contained inscribed writing-paper and beautiful little gold pens.

Presentation formed an important part of all these unique items. To give but one example, the miniature mirror, brushes, comb and scent-bottles, shoe-horn and powder-box – which comprised one of Aux Tortues' two dressing-table sets – were first fitted into an ivory box, decorated with hand-painted roses; this box was then placed inside a pink sealskin case which was lined with white satin. The second set comprised eight blond tortoiseshell pieces, which were fitted into a blue sealskin case similarly lined with white satin.

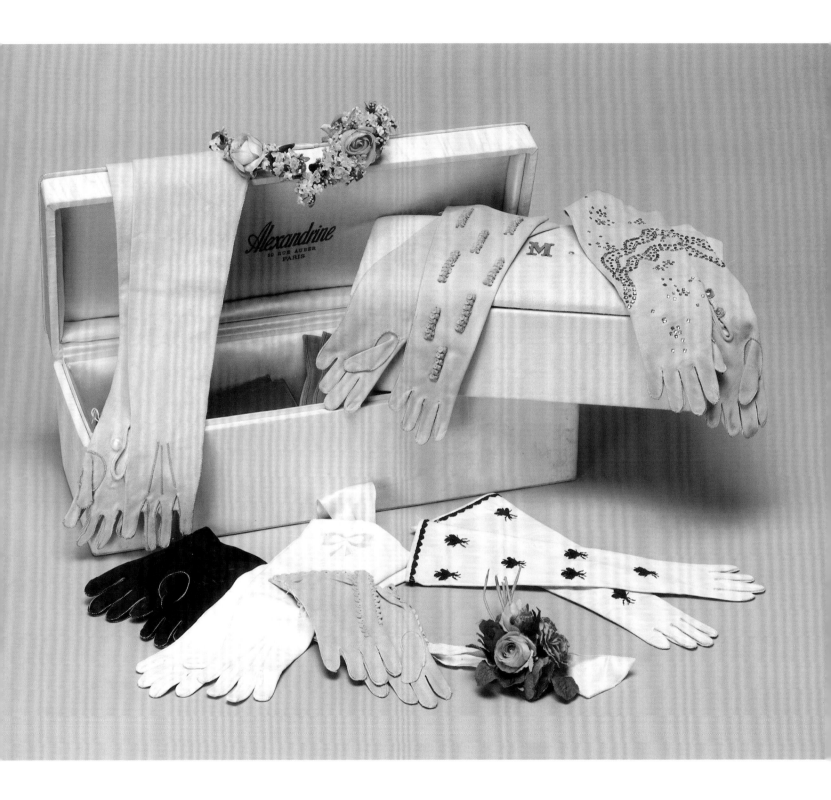

Accessories that attracted great admiration at the exhibitions were the gloves in their monogrammed satin boxes. Hermès made some plainer, wrist-length pairs, but these three-quarters and long examples, often most beautifully embroidered to match design details on dresses, were made by Alexandrine.

The two leather writing-cases
from Maquet are fine enough
to grace the most elegant setting.
Both cases and stationery bear the
dolls' monograms and each has
been given a miniature gold pen
to complete the charming gift.

All the dolls' possessions were finely cased. The pink satin lining of L.Rouff's white leather case shows off to perfection the delicate lawn handkerchiefs embroidered with the dolls' names, whilst Aux Tortues' blue leather silk-lined box and Cartier's white velvet-lined case enhance the tortoiseshell pieces and coral jewellery they hold.

Everything had been crafted with immense care and attention to detail, from
Cartier's traditionally boxed coral and lapis lazuli sets of jewellery (p.117) to Citroën's
two scaled-down replica cars. These were perfect miniature 1938 models of the two-
seater roadster version of the 7CV Traction Avant, André Citroën's 1934 front-wheel
innovation. Following his death a year later, his company was taken over by Michelin
and the two cars for France and Marianne were specially made to order by the AEAT
(Les Anciens Etablissements Ansart et Teisseine) coach-builders at Neuilly.

Both the 1.5-metre (4 ft 11 in.) long cars had opening doors and working head-
lamps. As befitted bespoke models destined for English owners, they were given
right-hand drive. The one made for France had her customised number-plate F.1938
and was cornflower blue in colour; Marianne's model was olive green and bore an
M.1938 plate.

Sports cars were, of course, the perfect choice for 'the ambassadresses'' transport,
but the 'little girl' dolls' needs had not been forgotten. Their special dark-blue
perambulators and wheeled cots were supplied by Le Nouveau Né. Though the
basic design of the cots was the same, with deep boat-shaped wooden coachwork,
their finished appearance differed considerably owing to the construction and

Citroën's two miniature sports
cars were specially made and
thoughtfully given right-hand
drive. Their two number plates,
F.1938 and M.1938, made sure
that France owned the blue and
Marianne the green model.

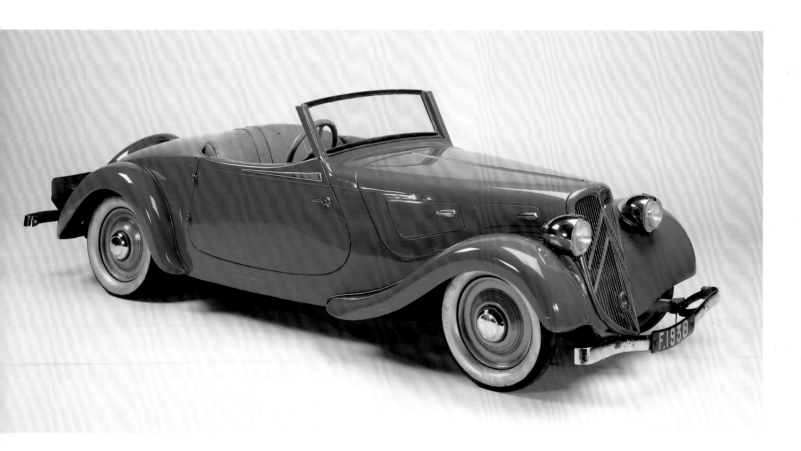

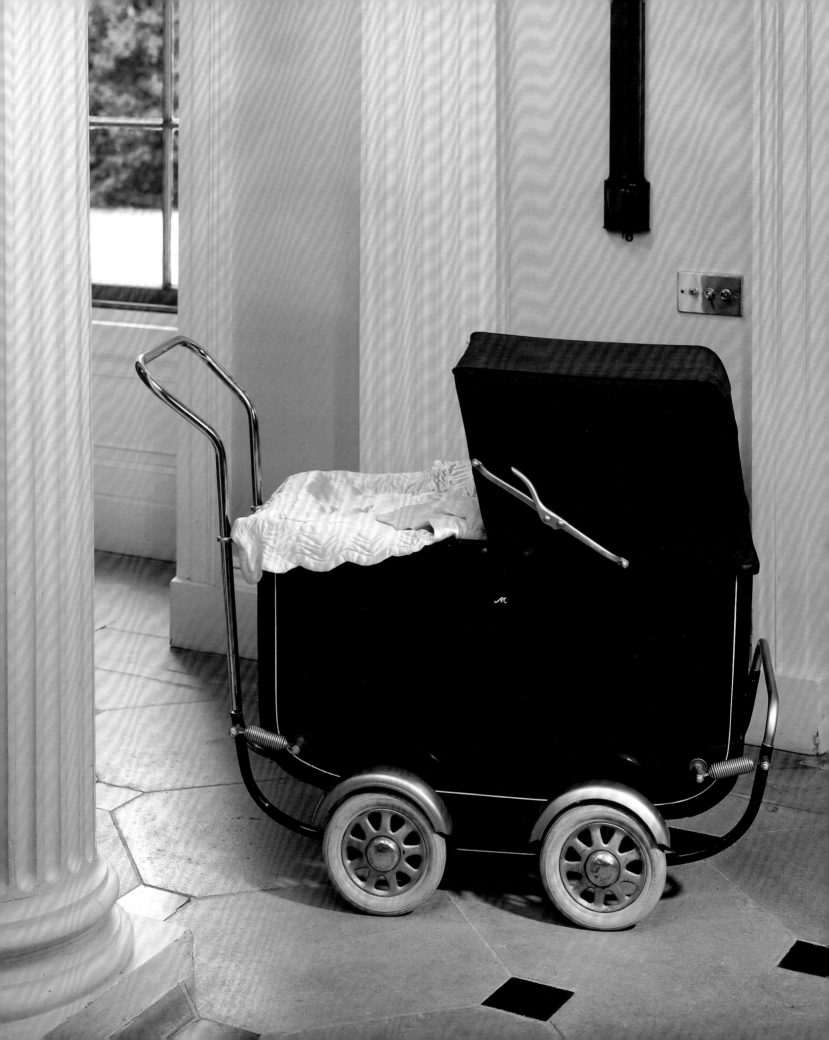

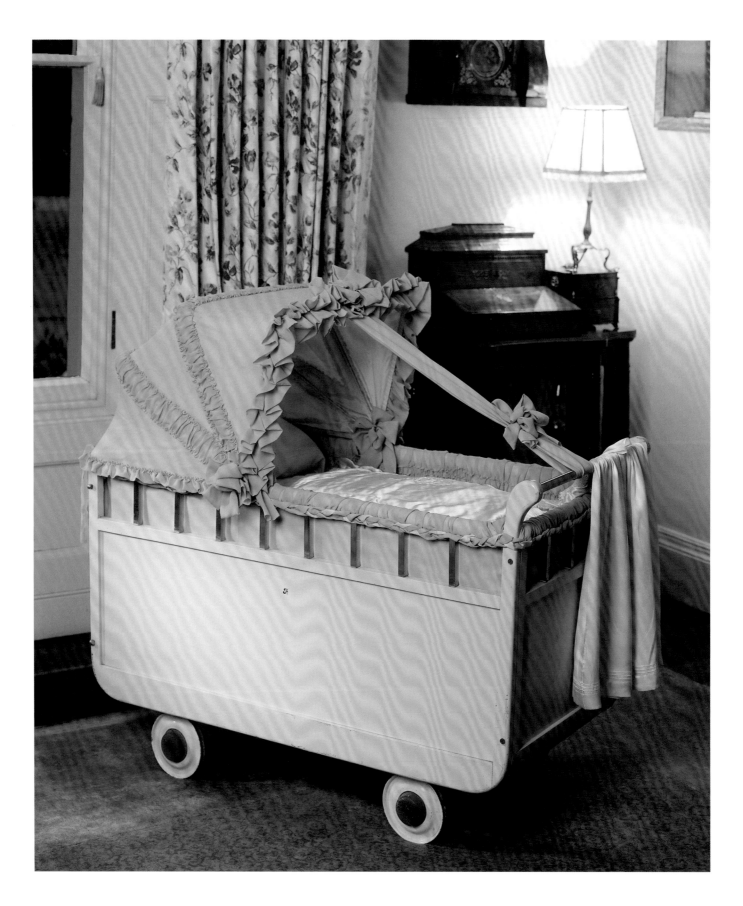

OPPOSITE: Le Nouveau Né provided two cots with differently designed covers. The blue cot's hood was square whilst the pink version had a triangular drape shielding its pillows.

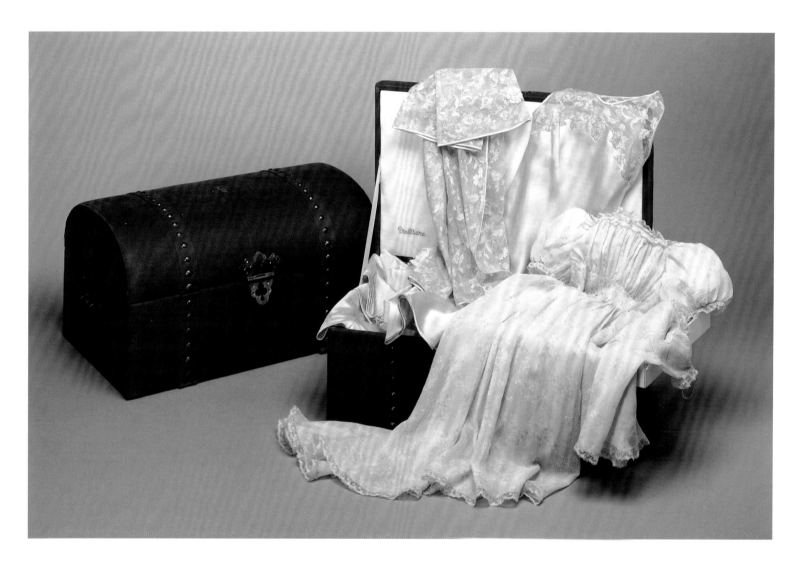

Valisère made the dolls' two small dress-trunks. Exquisite examples of lingerie and nightwear came from Charmis, Suzanne Joly and Aux Mille et Une Nuits.

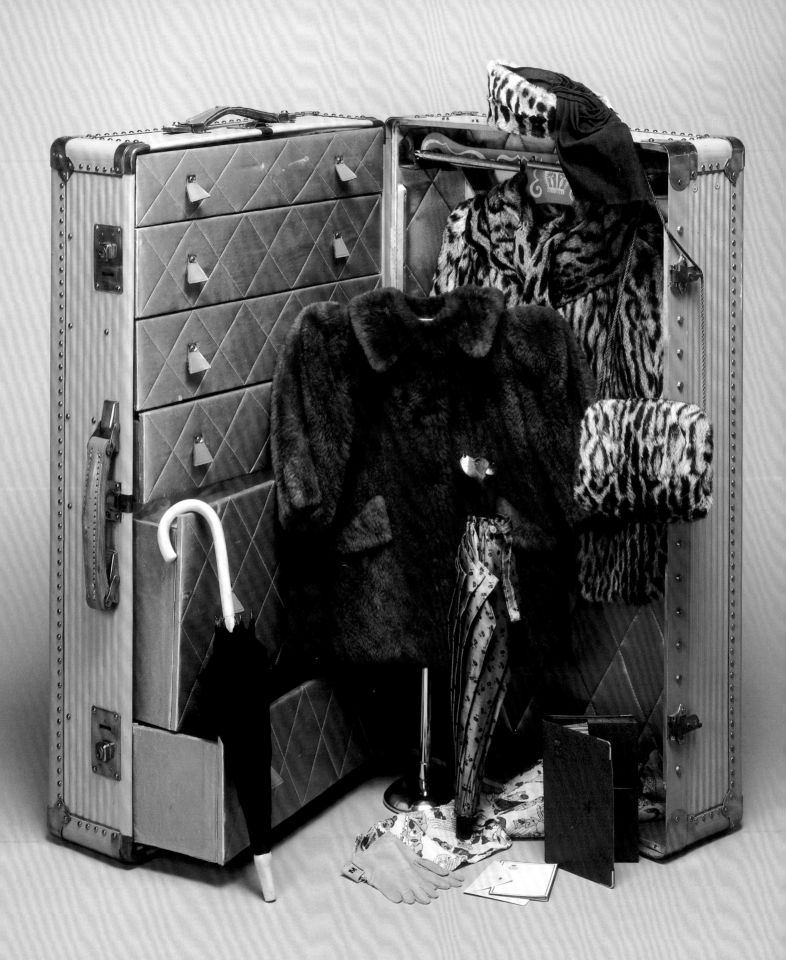

drapery of the upper framework. The pale-blue cot had a ruched hood to match the cot's interior lining; while the pink version, with a similar ruched lining, had a triangular-shaped drape curtaining its pillows. Both cots had white-satin-padded and fur-lined covers with the monogram F or M embroidered on them.

As several inaccurate descriptions of the dolls' luggage have appeared, perhaps it should be on record that there were only six pieces of actual luggage (excluding the many leather and satin-covered presentation boxes).

The two pale-blue cabin-trunks are the largest, being 81 cm high x 48 cm wide x 28.5 cm deep (32 x 19 x 11 in.), and their pale-blue-padded interiors are divided into railed hanging spaces on one side and tiers of drawers on the other. One of these wardrobe-trunks has M for Marianne painted in a deeper-blue decorative design on its lid; the other has F for France. Both pieces were supplied by Innovation.

Valisère made the dolls' two brown suede-covered dress-trunks, which are next in size – 24.5 x 49.5 x 28.8 cm (9½ x 19½ x 11 in.); they have fitted trays and bear the dolls' monograms in gilt. The two polished darker leather dressing-cases came from Vuitton and are 32.5 x 52 x 26.5 cm (13 x 20½ x 10 in.).

Though it can hardly be described as luggage, mention should also be made of the white leather box in which the beautiful doll-size porcelain Sèvres tea-set was presented. Not only was it padded and lined with white satin, but its base had been constructed to display and support each piece of porcelain separately – an important consideration when packing fragile items for transport.

All these items were included in the exhibition at St James's Palace, a display in which Queen Elizabeth took a personal interest. Not only did she consult Mr Symonds, Reville's managing director, about the arrangement of all the exhibits, but she also found time to visit the state room to see the final result before the exhibition opened.

OPPOSITE: Each doll had a cabin-trunk from Innovation. This one, belonging to France, is used to display the fur coats from Max and Paquin, with an assortment of accessories. The deep padded drawers opposite the railed section were for lingerie and shoes.

The delightful Sèvres tea-set, scaled down to doll size, was naturally presented in its own monogrammed leather case.

Henri à la Pensée was one of the designers who created items for the dolls' adult and juvenile trousseaux. The two elegant little beaded evening bags were perfect accessories for 'the ambassadresses', whilst equally attractive to 'the little girl dolls' was the scarf's design, based on Walt Disney's seven dwarves.

All who had been involved in the making of the trousseaux, *The Times* pointed out in its review on 9 December, 'had treated France and Marianne as seriously as they would have treated two real young girls when choosing the colour and styles suited for blonde and brunette, several of them specifying which doll had to have a particular model'.

It was not only the designers of the elegant adult items who created fashionable clothes and accessories for France and Marianne. Henri à la Pensée, who supplied the dolls' exquisite beaded evening handbags, gave as much attention to the accessories that were made for their juvenile outfits. Two Henri à la Pensée scarves had designs based on characters in the newly released Walt Disney film *Snow White and the Seven Dwarves*, and they would have been extremely fashionable accessories in 1938.

Dolls in the Thirties

During the 1930s dolls representing well-known characters, in both real life and fiction, were extremely popular, and in 1938 manufacturers had a good variety from which to make their choice for best-selling lines. The favourite character dolls, on both sides of the Atlantic, were Shirley Temple, dressed in replicas of the costumes the child star wore in her many films, the Dionne quintuplets as babies and growing children, and fictional characters like Snow White and the seven dwarves. All these dolls were made in vast quantities by such firms as Ideal and the Alexander Doll Company in the United States and Deans and Chad Valley in England.

In addition to the immense number of dolls Chad Valley made of Walt Disney characters, the firm also produced a limited edition of Princess Elizabeth and Princess Margaret Rose dolls in the late 1930s. Owing to the publicity given to the French gift of the two dolls to the Princesses, considerable interest was aroused in these new 'personalities'. Naturally, little girls in France and elsewhere longed for their own France and Marianne dolls.

The originals were Jumeau creations and, obviously, could not be copied without infringing regulations; however, SFBJ (Jumeau) did themselves bring out a very limited edition of two dolls named France and Marianne. Though basically they appeared to be replicas of their namesakes, there were noticeable differences – mainly in their dresses, but also in the dolls themselves.

The SFBJ look-alikes had good quality, but 'ordinary' sleeping dolls' eyes and their wigs – which, unlike the originals' bespoke wigs, were both parted on the same side – were commercially made. The quality of their bisque heads was slightly less fine and deeper in colour than those made for the original France and Marianne and their height also differed. Look-alikes were made in two sizes, the smaller being 45 cm (18 in.) and the larger 90 cm (35½ in.) tall.

The most obvious difference was in the dolls' clothing. Needless to say, these look-alikes did not possess any copies of items in France and Marianne's trousseaux. The outfits worn by the two 'replicas' were simply based on styles designed for the originals. 'France' was costumed in a white dress with two small posies of flowers on the long skirt and a blue ribbon sash; the bodice had puff sleeves and little buttons down the front and the outfit was completed by a jaunty white hat with blue ribbon bows. 'Marianne's' long-skirted dress was pale blue, with bands of lace – curiously, the dress differed sometimes from its own design for in some advertisements there were three bands and bows ornamenting the bodice and

The SFBJ made a limited edition of 'replicas' of France and Marianne. Both these 45 cm (18 in.) dolls and the larger 90 cm (35½ in.) version were attractive, though they lacked the originals' fine quality and, of course, unique trousseaux. The 'replicas' had mouths which were darker on the upper and paler on the lower lips; the original dolls' mouths were a single shade.

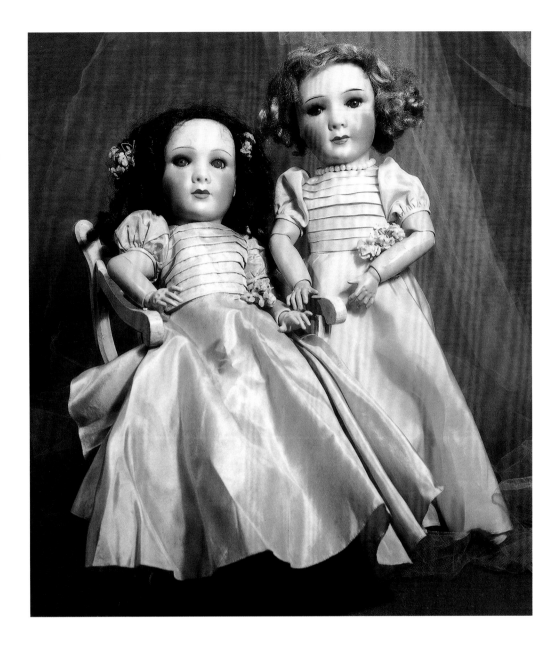

in others, noticeably that of the Galeries Lafayette, there were only two, slightly wider ones.

All the illustrated advertisements described the dolls as *reproduction des Poupées offertes aux Princesses Royales d'Angleterre* and the price for a 45 cm doll was 22.5 francs, according to the Galeries Lafayette advertisement.

The differences in quality and dress design are perfectly understandable and only to be expected; but what seems inexplicable, given the publicity the original dolls had received only a short time before, is the changes made in the dolls' identity.

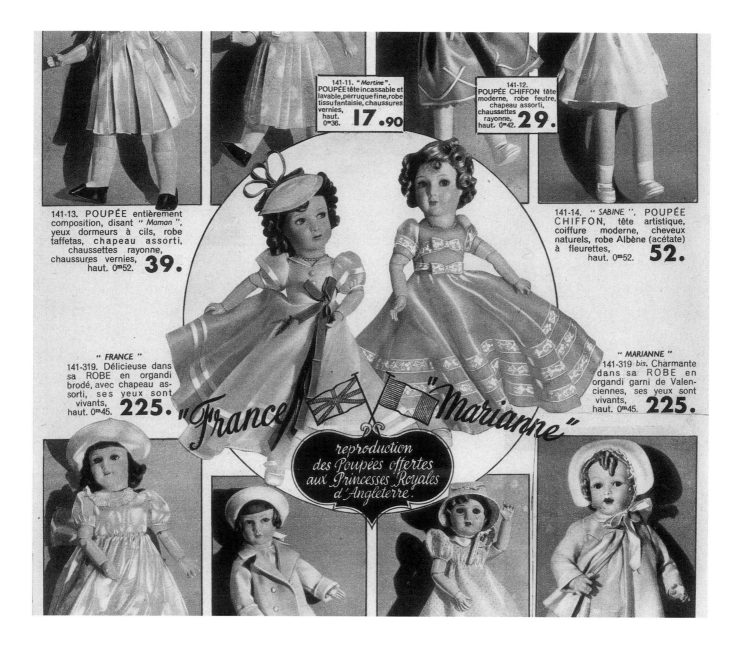

141-11. "Martine".
POUPÉE tête incassable et
lavable, perruque fine, robe
tissu fantaisie, chaussures
vernies,
haut.
0ᵐ36. **17.90**

141-12.
POUPÉE CHIFFON tête
moderne, robe feutre,
chapeau assorti,
chaussettes
rayonne,
haut. 0ᵐ42. **29.**

141-13. POUPÉE entièrement
composition, disant "Maman",
yeux dormeurs à cils, robe
taffetas, chapeau assorti,
chaussettes rayonne,
chaussures vernies,
haut. 0ᵐ52. **39.**

141-14. "SABINE". POUPÉE
CHIFFON, tête artistique,
coiffure moderne, cheveux
naturels, robe Albène (acétate)
à fleurettes,
haut. 0ᵐ52. **52.**

"FRANCE"
141-319. Délicieuse dans
sa ROBE en organdi
brodé, avec chapeau as-
sorti, ses yeux sont
vivants,
haut. 0ᵐ45. **225.**

"MARIANNE"
141-319 bis. Charmante
dans sa ROBE en
organdi garni de Valen-
ciennes, ses yeux sont
vivants,
haut. 0ᵐ45. **225.**

"France" "Marianne"

reproduction
des Poupées offertes
aux Princesses Royales
d'Angleterre.

France herself was blonde and Marianne brunette, yet in several illustrated
advertisements the blonde doll is labelled 'Marianne' and the brunette 'France'.
The occasional confusion over their correct names which the original dolls had
experienced seemed also to have affected their replicas. They, in their turn, were
involved in yet another mistaken identity myth, which this time developed in
the United States.

A Los Angeles department store had imported a few pairs of the dolls from Paris.
These, being the first to be sold there, excited the interest of doll collectors and

The advertisement of the
Galeries Lafayette in Paris shows
an error that occurred early in
the dolls' story; this blonde doll
is labelled 'Marianne' and the
brunette 'France', a reversal of
the original dolls' colouring.

There is a replica doll in the
Royal Collection. This doll,
though re-dressed in a perfect
miniature version of the old
Women's Voluntary Service
(WVS) uniform, is in fact a
France replica. The marks on
the doll confirm its origin.

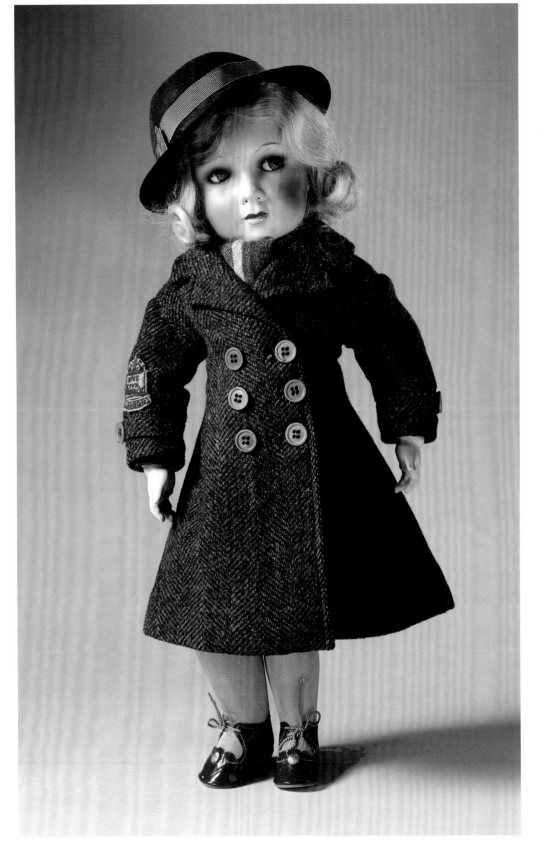

were quickly purchased. When these dolls were later exhibited in regional and national shows, they were described by some writers reporting the events not as replicas of the dolls made as a gift for the English Princesses, but as 'dolls made to represent England's Princess Elizabeth and Princess Margaret Rose'. The brunette 'Marianne' was identified as Princess Elizabeth and the blonde 'France' as Princess Margaret, even though, in fact, both Princesses had the same hair colour, mid brown with fairer highlights.

As in those days any pictures of the Princesses which appeared in newspapers, magazines or newsreel films would have been in black and white, not colour, the differing hair shades would not have been remarkable perhaps. It does, however, seem strange that any serious collector could accept the France and Marianne look-alikes as portrait-dolls of the two Princesses.

The picture of these two replica dolls which was used for their advertisement illustration does appear in at least one book on dolls with the caption 'The Princess dolls: lovely 32-inch [81 cm] French bisques of the Princesses Margaret Rose and Elizabeth'. The author also refers to them in the text as 'dolls representing Princess Elizabeth and Princess Margaret Rose', thus conferring on the replicas the double honour of representing not only the original France and Marianne but also their royal owners.

Very few children could own these special edition dolls, but most little girls who were fascinated by the royal dolls and their marvellous clothes might have a book of France and Marianne paper dolls. They could carefully cut out first the dolls appearing on the front and back covers, and then the pages of clothes inside the book to dress them.

Paper and cardboard cut-out books were immensely popular during the 1930s. Millions were produced on both sides of the Atlantic, featuring film-stars, fashion models, modern children and famous personalities. Raphael Tuck was one of the best-known English publishers of this type of toy. The firm did produce a cut-out book of one unique gift made to a princess at that time though their choice was not France and Marianne, but a cardboard model of the little 7.3-metre (24 ft) wide house Y Bwthyn Bach (The Little Thatched House) that the Welsh people gave to Princess Elizabeth on her sixth birthday.

It was an American publisher, Whitman Publishing Company, that printed a cut-out book of the royal dolls in 1940. Even in this form of presentation, the dolls encountered problems of identity. The book had black-haired and yellow-haired cut-out dolls on its covers and pages of outfits inside with which to clothe the dolls.

OVERLEAF: Strangely, it was an American publisher, Whitman Publishing Company, which printed this paper-doll book. Although the dolls, unlike their cut-out clothes, are not identified by name, they are described as 'Dolls of the Royal Princesses' on the cover.

Dress for a Garden Party
and Hat of faille by
Jeanne Lanvin

THE PRINCESS PAPER DOLL BOOK

The Two Royal Princesses of England
ELIZABETH *and* MARGARET ROSE

All the illustrations of the clothes were authentically drawn and each couturier was correctly identified – which makes it all the more interesting that the dolls' names were not mentioned. The book is entitled *Cut-outs from the Dolls of the Royal Princesses of England, Princess Elizabeth and Princess Margaret Rose.* The front cover lists fifteen couturiers under the subtitle *Designs by the Famous Fashion Designers of France.*

The same company also produced *The Princess Paper Doll Book* in similar format. This book had a Princess Elizabeth and a Princess Margaret Rose paper doll to cut out of the back cover and pages of outfits for dressing the dolls inside.

One English company, J.W. Spear and Sons, had produced a 'Magic Dressing Doll' of Princess Elizabeth in 1937. This paper doll with 'magnetic' outfits was subtitled 'A Princess of your own' and the box cover showed a coroneted and robed princess. As 1937 was the coronation year of King George VI, this was probably designed as a souvenir. Unfortunately they did not produce a similar box of delights for France and Marianne.

Like their dolls, the two Princesses also featured in a cut-out paper-doll book. Their clothes also were printed on the book's inside pages and the Princess dolls were cut out from the cardboard cover and fixed to similar stands.

The dolls on exhibition in Scotland and Canada

Le Journal's reports about France and Marianne ended with an account of the 1938 exhibition at St James's Palace. The most extraordinary part of the dolls' story was yet to come: their hazardous wartime trans-Atlantic journey to Canada, fund-raising for refugees.

Before this 'unique undertaking' – as Her Royal Highness Princess Alice, Countess of Athlone, described the dolls' royal progress across Canada – they had been sent to Scotland in August 1939 to raise funds for King George V's Jubilee Trust. The exhibition was opened in the McClellan Hall in Glasgow by the Lord Provost, P.J. Dollan, on 21 August, Princess Margaret Rose's birthday. The Princess had been born in her maternal grandparents' home, Glamis Castle, and her ties with Scotland were therefore felt to be especially strong.

The following day *The Times* carried a report from Glasgow about 'the Exhibition of Mlles. France and Marianne, which were given to the King and Queen for the two Princesses during their Majesties' State Visit to France last year. Each doll has a full wardrobe of dresses for all occasions.' It added that 'a telegram of congratulations on her ninth birthday was sent to Princess Margaret Rose from the children present at the opening'.

The Glasgow exhibition was scheduled to close on 9 September, when the dolls and their trousseaux were to be packed up to move on to Edinburgh for their next display before going further north for more public appearances. However, on 3 September the Second World War broke out and plans for the dolls' fund-raising projects in Britain were immediately altered.

Earlier that year, in the spring, King George VI and Queen Elizabeth had made another diplomatically important royal visit, this time to North America. Their ship had been scheduled to arrive at Quebec on 15 May but was delayed by dense fog and icebergs and could not dock there until 17 May. A brief four-day visit to the United States formed part of this very busy tour, and both there and in Canada Their Majesties were warmly received. Again, they achieved considerable personal success and gained influential support at a very crucial point.

The Canadian prime minister accompanied the King and Queen to the United States. It is on record that, whilst in New York, he received an urgent letter from Cairine Wilson, Canada's first female senator, regarding her concern over the number of people – particularly children – who were being forced to leave Germany to escape Nazi persecution. Senator Wilson was tireless in her efforts to persuade

Senator Wilson, chairman of the Canadian National Committee on Refugees before and during the Second World War, had been a Canadian senator since 1930. It was through her efforts that France and Marianne went on their fund-raising mission in Canada during 1940 and 1941.

Canada to accept at least some of the refugees who had managed to reach England. Unlike many of her compatriots at that time, she realised the extent of the problem for a country trying to cope with a growing number of refugees whilst being fully stretched preparing for an almost inevitable war.

Even before her marriage to Norman Wilson, the Liberal MP for Russell in Ontario in 1909, Senator Wilson had been involved in politics; she often went with her Liberal senator father to stay with the prime minister in Ottawa. She herself became a senator in 1930 and was Canada's first woman delegate to the United Nations General Assembly in 1949. She was also, amongst other appointments, chairman of the Canadian National Committee on Refugees (CNCR). For her work for this cause she was made a knight of the Legion of Honour (France) in 1950.

Few people initially realised the magnitude and seriousness of the international refugee situation, so the 'Mother of Refugees', as Senator Wilson was later called, had an extremely difficult task in the late 1930s and early war years. However, in response to a broadcast appeal by the British prime minister, Stanley Baldwin, the CNCR had been formed, with her support, in 1938. From then onwards Senator Wilson actively sought the publicity necessary to raise funds to help bring refugees, particularly children, to Canada.

The success of the 1938 exhibition of France and Marianne at St James's Palace in raising funds for the Princess Elizabeth of York Hospital for Children had been widely reported on both sides of the Atlantic. Possibly the suggestion that the dolls might be permitted to come to Canada to aid the refugees was made to Queen Elizabeth during the royal tour of North America in 1939. Certainly, when the request was received, Her Majesty willingly gave her permission.

Senator Wilson and Mrs Cooke, chairman of the Ottawa branch of the CNCR, were appointed to head the sub-committee which would be responsible for arranging the dolls' transport and displays.

Local committees were asked to assist by advertising exhibitions due to be held in their regions. When approached, the Canadian National Railway offered help in arranging the itinerary and packing facilities; they also agreed to provide free transport for the dolls and their entourage. Several large department stores, most notably Charles Ogilvy Limited and the T. Eaton Company, also offered assistance, providing venues for the exhibitions throughout Canada and help towards the cost of running the project, which was due to last for at least a year.

Senator Wilson and Mrs Cooke were in overall charge at the Ottawa headquarters, but someone was needed to travel with the dolls and be responsible for their care on a day-to-day basis. This somewhat nerve-racking task was undertaken by Miss Christina Beaith, who had been working for the refugees' organisation in Ottawa. During the thirteen months of the tour she was to have exactly one day free from her duties. Nevertheless, Miss Beaith insisted that – though she had never worked so hard for such a long, unrelieved period – she could not remember feeling happier working on any other project.

Reporters who described the displays referred to her variously as the dolls' 'lady-in-waiting', 'attendant' or 'manager'. Miss Beaith herself, having no official title, said she was content to be called anything they liked save 'manager'; this, she said firmly, she could never feel in relation to her royal charges.

Newspaper coverage of the dolls' coast-to-coast tour helped to ensure its success. Miss Beaith, normally working at the headquarters of the CNCR, accompanied the dolls throughout the thirteen-month tour and supervised every display en route.

That she regarded France and Marianne with some affection is perhaps demonstrated by her own description of the two dolls. When, after her usual introductory speech at exhibition openings, she was asked to describe them, she said France represented aristocratic France whilst Marianne was 'one of the people' – a rather interesting and, perhaps, unexpected observation.

Throughout the long tour, Miss Beaith packed and unpacked, dressed, tidied and re-dressed the dolls for all their exhibitions, took them to visit hospitals and a beauty parlour, supervised sessions in photographic studios for 'portraits' and the set of picture postcards depicting the dolls and their possessions in various scenes.

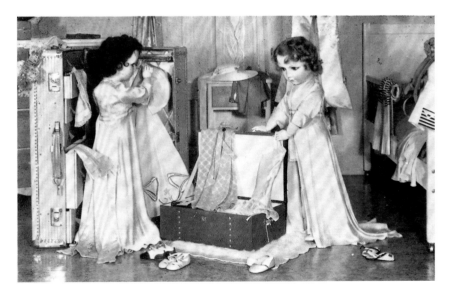

The sale of specially posed picture postcards, which were photographed and printed in Canada, helped to swell the funds raised for refugees by the dolls' exhibitions.

The Aim of the National Committee on Refugees

is to establish skilled refugee workers in Canada in the same industries in which they were employed before they fled from German domination.

With the tremendous development in synthetic materials of the last few years, and the industrial development forced on Canada by the war, we believe there is room in this country for many more people, both now and in the future when we look for peace.

We have urged continuously on the government the admission of workers and firms valuable to Canada and many of them have been admitted. Among the things to be manufactured in this country by refugees are: shoes, jewelry, plastics, art glasswear, cheese, handicrafts, textiles, toys, artificial flowers, sugar, aluminum products, pottery, gloves, specialty steels, shirts, collars, industrial chemicals, ply-wood, fur garments.

It has been estimated that for every foreign worker and industrialist admitted, ten Canadians have been given employment in these industries.

Numerous minor problems are handled by the local committees, volunteers are furnished to Children's Aid Societies; relatives or lodgings are found for immigrants; transportation may be paid for those stranded in European ports; short-time loans are occasionally made or other help extended as required. Above all, we try to greet the new-comers with kindliness and sympathy and to understand their problems. No effort is spared to fit the refugee quickly into Canadian economic life and to make him feel proud to belong to the British Empire.

France and Marianne
The Princesses' Dolls

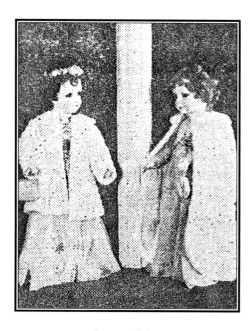

**Loaned by
HER MAJESTY THE QUEEN**

to the Canadian National Committee on Refugees for the benefit of European Refugees and those evacuees from Britain who do not come under the Government scheme

A leaflet was also printed which gave some information about the CNCR's work for refugees as well as a few details about the making of the dolls and their trousseaux.

However much help she was given, and even though the dolls had their own body-guard upon occasion, the responsibility for their well-being was hers alone; it must have been a stressful task, despite the pleasure that she felt in accomplishing it.

France and Marianne arrived in Ottawa at the CNCR headquarters in August 1940. Obviously, photographs of the dolls were taken prior to the exhibition opening so that the newspapers could publish them to promote interest, but, rather surprisingly, France and Marianne also featured in a beauty salon's advertisement.

The dolls had presumably been taken to the salon to ensure that their hairstyles would look immaculate for the important occasion. However, it is something of a shock to see them posed in front of mirrors with their stylist and to read:

Laura Thomas is hairdresser by appointment to the Royal dolls . . . see how Marianne wears the stylish new Pompadour, lustrous waves sweeping up in glistening beauty, and France, her blonde locks a riot of tendrils in the lovely cascade curl. The famous Royal dolls now visiting Ottawa demonstrate how Laura Thomas's coiffure artists can design an individual hair-do for you in the flattering new fashions of the hour.

The exhibition at Charles Ogilvy's department store was opened on Saturday 14 September by Mayor Lewis. Princess Alice, wife of the governor general of Canada, the Earl of Athlone, was unable to be in the capital at that time due to duties elsewhere. Being the Princesses' great-aunt (her husband, the Earl of Athlone, was the younger brother of their grandmother, Queen Mary) as well as a distant relative by birth, Princess Alice was particularly interested in the dolls. She sent her regrets at not being able to open their first exhibition and her best wishes 'for this unique undertaking's success'.

The Ottawa exhibition was in fact very successful, raising a gratifying amount for the CNCR through its admission fees (25 cents for adults and 10 cents for children, charges which applied throughout the tour). There were also receipts from the sale of the picture postcards and a small leaflet which briefly set out the aims of the CNCR and gave some details about the dolls and their trousseaux.

Reading the numerous newspaper reports covering all the exhibitions in the cities visited by the dolls, it is interesting to note the differences in the various accounts. Though, of course, all of them of necessity printed identical basic information, each city's reporters seem to have found a different approach or point of interest for their readers. In Hamilton, for instance, having stated that the opener at Eaton's was Mrs L. Stephens, president of the local council of women which had sponsored and

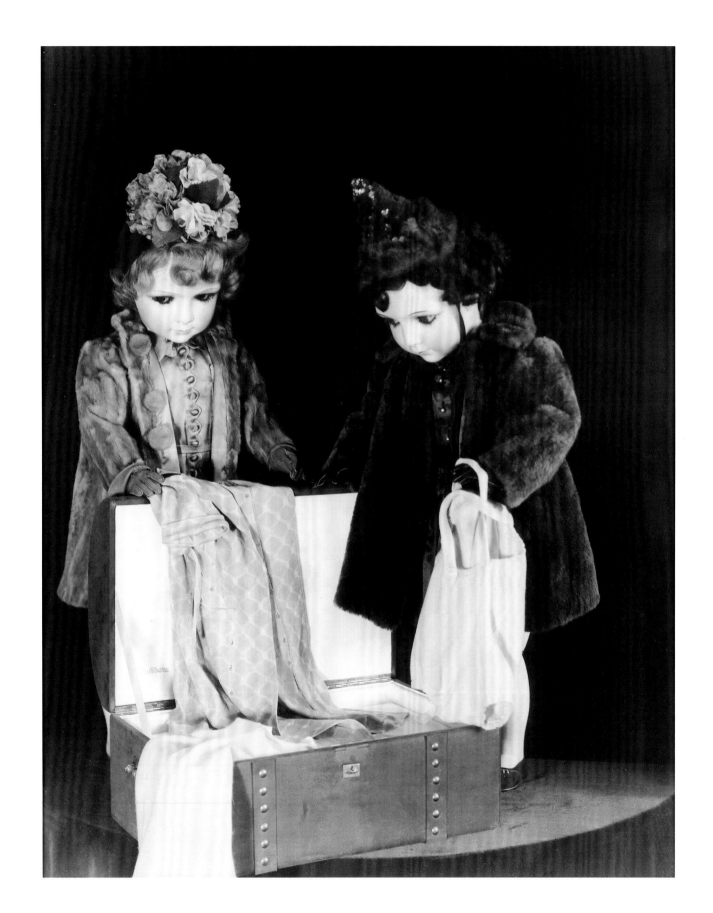

staffed the display, the writer became intrigued by a detail of Marianne's lace dress. She described the working of regionally costumed Breton figures into the pattern of the lace forming the border of the long dress, a detail which could be seen only on close inspection.

Bearing in mind the fame of Canada's fur trade, it is not surprising that the miniature fur capes and coats of the royal dolls attracted attention; and it would have gratified the makers of the trousseaux had they known how many small details of fabric pattern and shoe design were noticed and appreciated.

Montreal newspapers had several special-to-this-city items to record, the two most important events being HRH Princess Alice's connection and the dolls' precarious expedition to two children's hospitals in the city. As Princess Alice had been unable to open the dolls' Ottawa exhibition, she went to Montreal specially to open the display there and to give her good wishes for the tour's success in person.

The CNCR marked this visit of the governor general's wife with a special advertising campaign, and issued 200 invitations to a private view of the display before the official opening. In addition, they printed posters and leaflets, in both French and English, which gave information about the dolls and their unique trousseaux. These leaflets were not only available at leading stores; bakeries, laundries and dairies volunteered to distribute them throughout the city.

Newspaper stories and pictures appeared frequently in the weeks prior to the Montreal exhibition and a trailer to be shown in some cinemas was arranged by the CNCR committee. Members of the committee were in attendance throughout the two weeks and were responsible for tickets and cash.

It is difficult to calculate the exact number of children who saw the dolls throughout the tour as they were admitted free with an accompanying adult's ticket before 11am each day. However, it would seem some 19,566 of those adult tickets were sold during the fortnight that France and Marianne were on display in Montreal, which gives an indication of the popularity of the exhibition.

Even the intrepid Miss Beaith must have had some particularly worrying moments on the Sunday before the opening, when France and Marianne made a rare appearance in public outside their exhibitions. In order that the small patients in the two children's hospitals there, Shriners and the Children's Memorial Hospital, should not be denied the once-in-a-lifetime pleasure of seeing the Princesses' dolls, they were taken to make a tour of the wards. That allowed the children, many of them bedridden, to touch as well as see these unique treasures. Although this was a heart-warming idea, the realisation of the damage that could have occurred

OPPOSITE: The dolls' fur coats were, naturally, of special interest in Canada and this photograph appeared in several newspapers. Marianne is holding one of the hand-knitted bathing costumes from Henri à la Pensée.

Princess Alice, with her husband the Earl of Athlone (a great-uncle of the Princesses) and members of their staff. The earl was governor general of Canada during the war and the Princess, who was a granddaughter of Queen Victoria, had therefore a double interest in her young relatives' dolls and their fund-raising in Canada.

to these breakable royal dolls must make any collector's hair stand on end.

Princess Alice came to Montreal to open the exhibition at Eaton's department store on 8 October and, speaking firstly in English and then in French, drew attention to the Princesses' kindness in giving up their dolls for so long a period to aid the CNCR. She said that France belonged to Princess Elizabeth and Marianne to Princess Margaret Rose but up to now neither child had, to quote their own words, 'ever been able to enjoy them'. Certainly the dolls had been either on display somewhere or in transit for most of the time since they were presented.

Some time after Princess Alice and her party had left the exhibition, its organisers were surprised to see the Earl of Athlone entering the room. According to one reporter still 'on duty', he said he had been unable to be there earlier and felt he had to make the unexpected visit as 'he could not resist the opportunity to see the dolls he had heard so much about'.

Rather curiously, another story about dolls and their specially created clothes was featured by the *Montreal Gazette* on 11 October – during the royal dolls' visit there, though no mention was made of this in the article. It concerned a Canadian doll donated by a Mrs Johnson. The Ladies' Auxiliary had spent six months making the pretty 'Princess Elizabeth' doll a wardrobe of clothes. Though it could not equal France's and Marianne's trousseaux, it contained fifty or so hand-sewn items of sportswear, day and evening outfits (including a fur coat), hats, shoes and lingerie. The newspaper stated that the doll and her clothes were to be displayed in various shop windows in the city to raise funds for the Children's Hospital before being given to some lucky little girl in November.

Mrs Matthews, wife of His Majesty's representative in Toronto, opened the France and Marianne exhibition in that city. She was one of the many women in Canada who were interested in French fashion and said in her speech that she believed Canadian styles would be influenced by the Parisian couturiers' trousseaux for the dolls. It was noted in the press that this would be very probable, for permission to

copy some of the dolls' dresses and reproduce them for full-size clients had already been sought by several Canadian designers.

The attraction of beautiful clothes is felt by women all over the world and, with the austerity and restrictions of wartime living drastically affecting pre-war customs of making suitable changes of dress throughout the day, the opportunity to see authentic – albeit miniature – examples of Parisian haute couture intrigued many Canadians. Days before the exhibition ended in Toronto, it was recorded that more than 13,000 people had already seen the dolls' trousseaux, which had been valued at over $10,000. Newspapers certainly gave the exhibitions full coverage throughout the tour. As the *Toronto Globe* pointed out, 'the Empire broadcast by Princess Elizabeth is increasing interest in the showing of the Princesses' dolls, especially as the Royal Children are sharing the common dangers in Britain'.

Another Toronto newspaper, the *Evening Telegram*, decided to add a masculine touch to their reports on France and Marianne and printed an article about Lieutenant Robert Thurneyssen of the French army. Following his active service on the Maginot Line, a line of defence between his country and Germany, he had been appointed liaison officer with the British army and posted to Canada. After the fall of France he could not rejoin his regiment and was detailed for 'special duties' in Canada – which, to say the least, must have been as unlikely a posting as he could possibly have imagined. Lieutenant Thurneyssen had been seconded, so to speak,

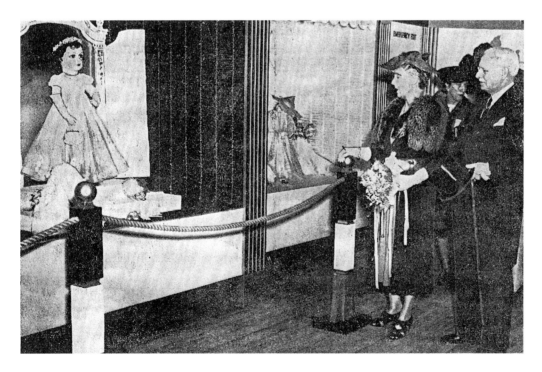

The Countess of Athlone's duties had prevented her from opening the dolls' first Canadian exhibition. However, she travelled specially to Montreal to open the exhibition there. This newspaper cutting shows how the dolls and their trousseaux were arranged in their many displays.

OPPOSITE: The dolls' leisurewear intrigued both Canadian viewers and professional designers. Marianne, wearing an outfit by Marcel Rochas, stands beside a printed silk dress by the same designer. During their tour several applications were received from designers for permission to make similar full-size garments for clients.

to the royal dolls' entourage and was to be responsible for their safety during the tour. That France and Marianne were to have as body-guard a French officer was, of course, appropriate – but it must have seemed an unexpected transfer even for a gallant Frenchman. It would have been interesting to have known more about his very unusual military career, but only this connection with the royal dolls was recorded by the press.

By the time the dolls reached British Columbia on Canada's west coast, which was the halfway mark of their expedition, over $15,000 had been raised for the CNCR.

Vancouver's *Daily Colonist* recorded that Viscountess Byng, widow of Canada's twelfth governor general, opened the exhibition there on 12 December, and their reporter described the setting arranged for each display. In 'show-window' style, twelve gold-framed recesses, approximately 1.8 x 2.4 metres (5 ft 9 in. x 7 ft 9 in.) in size, were lined with backcloths of alternating royal-blue and white pleated silk. These sets, of course, had to be dismantled and packed for transport to the next venue after every exhibition.

The transport details interested the *Edmonton Journal*, particularly the dolls' padded travelling-case, 'the twill lining of which was embroidered with the red poppies, white marguerites and blue cornflowers of France'. During transit the case was kept in the thermostatically heated private car reserved for the dolls and their entourage on every train.

The *Calgary Herald*, having noted that '4,977 adults and 3,452 children' had seen the display there, was one of the newspapers which specially mentioned the many children who would not otherwise have been able to see the dolls, but who were given that pleasure through the kindness of various local clubs which sponsored their visits; in Calgary nearly six hundred had benefited from the scheme.

Just occasionally, a reporter chose to strike an unexpected note; as when the *Leader-Post* of Regina headed its article 'Two "Royal" Evacuees Get Cool Welcome'. It went on to explain that no snub had been intended, for 'the two young ladies – royalty y'know – arriving in Regina in the cold, bleak dawn last Tuesday' were unaware of the non-appearance of civic officials to welcome them – being, though undoubtedly royal, only dolls.

This article mentioned that $25,000 had already been collected 'for *other* evacuee children' – thus linking the dolls, at present safe from the bombs devastating London, with the young refugees whom they had been sent to support.

Continuing their return journey east, the dolls still had several important places to visit after leaving Regina – cities such as Halifax, Moncton and Quebec. Quebec

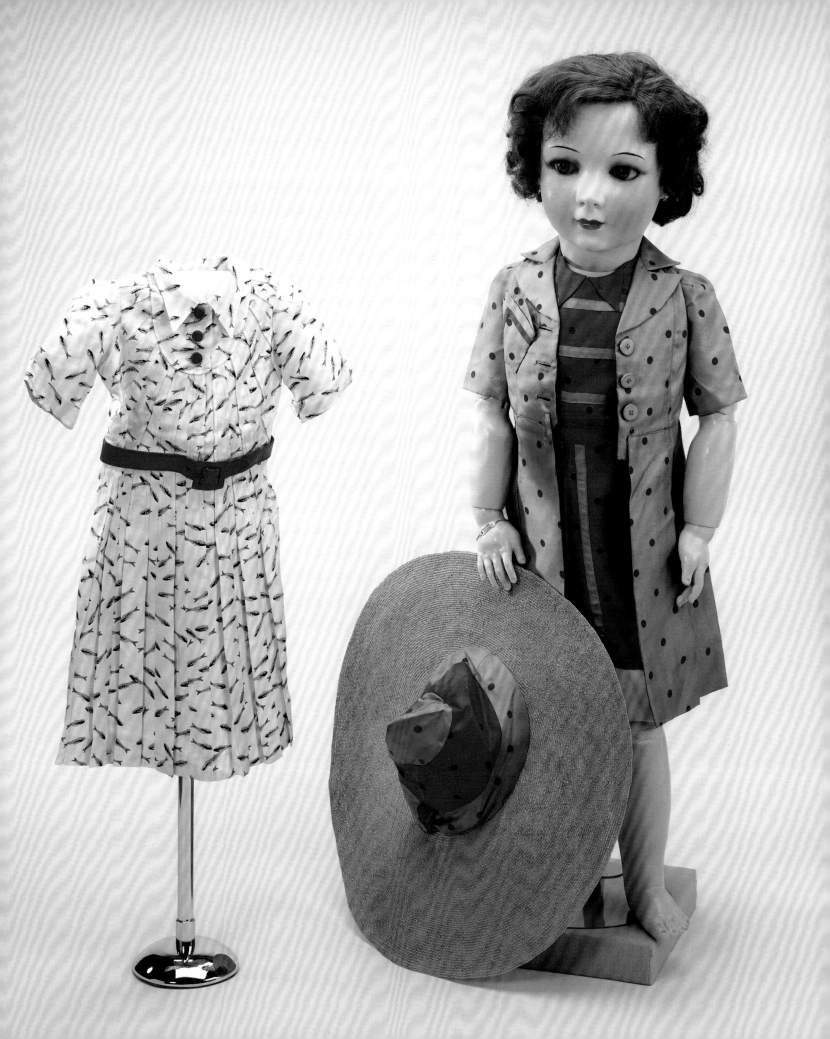

ITINERARY OF FRANCE AND MARIANNE'S CANADIAN TOUR

OTTAWA (Charles Ogilvy) 14 September – 2 October 1940

MONTREAL (Eaton's) 8 October – 22 October 1940

TORONTO (Simpsons) 26 October – 8 November 1940

HAMILTON (Eaton's) 12 November – 19 November 1940

WINNIPEG (Eaton's) 25 November – 7 (or 9?) December 1940

VANCOUVER (Hudson's Bay Company) 12 December 1940 – 3 January 1941

VICTORIA (Hudson's Bay Company) 9 January – 23 January 1941

EDMONTON (Hudson's Bay Company) 3 February – 18 February 1941

CALGARY (Hudson's Bay Company) 24 February – 8 March 1941

SASKATOON (Hudson's Bay Company) 15 (or 17?) March – 29 March 1941

REGINA (R.H. Williams, The Glasgow House) 4 April – 19 April 1941

ST THOMAS (Anderson's) 26 April – 9 May 1941

NIAGARA FALLS (Canadian Department Stores) 20 May – 31? May 1941

SYDNEY (Bonnell's) 7 June – 14 June 1941

HALIFAX (Eaton's) 20 June – 28 June 1941

MONCTON (Eaton's) 4 July – 12? July 1941

TRURO (organised by IODE) 16 July – 18 July 1941

CHARLOTTETOWN (Holman's) 24 July – 31 July 1941

QUEBEC (La Compagnie Paquet Ltd) 11 August – 23 August 1941

OTTAWA (Charles Ogilvy) 8 September – 13 September 1941

Immense organisation was necessary to arrange the tour. As the dolls were transported by train, their route was determined largely by the railways. All the main venues are shown, but 'whistle stops' in a few smaller towns may have been fitted in en route.

was to have been their last exhibition, in August 1941, but it was decided to add one more month to the itinerary and finish with a final, second visit to Ottawa. This last display again took place in Charles Ogilvy's store and brought the extraordinary venture to a very satisfactory conclusion on 13 September. The newspapers reported that more than 153,000 people had seen the royal dolls during the tour.

Their itinerary had been complicated and had been achieved only after much careful planning. As one Ottawa newspaper pointed out, just for the dolls' display to close in Regina and then open in the next venue, St Thomas, at the appointed time, six changes had to be made by the express car in which they travelled by rail.

Mrs Cooke, who had been largely responsible for the general management of the whole undertaking, paid a well-merited tribute to Miss Beaith, for 'her wonderful care of the dolls and her untiring efforts over the thirteen-month period of the tour'.

Sending the dolls to Canada was seen there as an example of Queen Elizabeth's particular desire to help organisations caring for refugees. The *Bradford Expositor* was one of several newspapers to use their reports on the dolls' exhibitions to express appreciation of this gesture and link it to a wider review of the Royal Family's involvement in the war effort: 'The Queen has set us a great example by her steadfastness and determination to do her full part.' At the same time they were impressed by the two Princesses' remaining in England and 'being very much brought up in the way they should go'.

The long journey of France and Marianne had begun under the aegis of Senator Wilson. It ended in Ottawa, when they were given into the care of Princess Alice at Government House – a fitting temporary residence for the two ambassadresses. Her Royal Highness had once spoken of her young relations' dolls as being 'symbolic of the departed days of a carefree and joyful childhood', but the *Winnipeg Free Press* saw France and Marianne in their ambassadorial role, describing them as 'serving their country touring Canada in the interest of refugees'.

In both capacities the dolls were unique and the successful planning and carrying out of their amazing wartime journey to and across Canada involved not only the main organisers at headquarters but all the local committees and volunteers along the route, coast to coast, and back again to Ottawa.

France and Marianne finally arrived home in England in 1946, when the Earl of Athlone's term of office as governor general of Canada ended and the six large crates containing the dolls and their possessions were included in the Earl and Countess of Athlone's luggage.

By that time, of course, both Princesses had grown up and their dolls' experiences

as fund-raisers were seen with adult eyes. France and Marianne were no longer the heroines of 'The Fairy-tale' created especially for them in 1938.

Real playthings the dolls had never been, but their usefulness in more important roles had made them the most internationally famous of all royal dolls by 1946. Their thirteen-month marathon journey made them by far the most effective and important royal doll fund-raisers, but they were not the only ones belonging to the Princesses that were used in this way during the war.

France and Marianne were not taken south of the Canadian border; however, their tour was no doubt the inspiration that caused five more of the Princesses' dolls to be sent on a smaller fund-raising mission to the United States in 1942.

On 6 May that year readers of the *Washington Daily News* were probably somewhat startled to learn that 'Royalty' had held a reception in the capital the previous day. 'Yesterday afternoon', the report began, 'the British Embassy here was again host to Royalty. Yes, once again, as nearly three years ago, Queen Elizabeth of England smiled down on guests gathered before the South Portico of the official residence of the British ambassador.' It went on, 'Don't get excited and think you've missed something in the way of an announcement', reassuring readers that this time 'Queen Elizabeth' was accompanied by three other dolls belonging to the English Princesses, Elizabeth and Margaret Rose, which they had allowed to be sent from England to raise funds for refugees.

Other American newspapers recorded that the ambassador's wife, Lady Halifax, presented the dolls to the president of the British War Relief Society, Robert Appleby, who had flown down from New York for the ceremony. Lady Halifax told guests that the Princesses had asked for any money raised by the displays of the dolls in the United States to be given to the charity, which provided homes for refugee children.

The five dolls had been dressed by two of England's best-known couturiers, Captain Edward Molyneux and Norman Hartnell, and then been given by the designers as gifts to the two Princesses. Though three of the dolls had been costumed as young children and looked most attractive in party frocks and an outdoor outfit, it was the other two dolls that caught the attention of the press. Both these dolls represented Queen Elizabeth and had been attired by Norman Hartnell in miniature replicas of the evening dresses Her Majesty had worn to functions in Washington during the brief royal visit made to the capital when the King and Queen were visiting Canada in 1939.

King George VI had suggested, when Norman Hartnell was designing Her Majesty's clothes for the first State Visit to Paris in 1938, that perhaps a

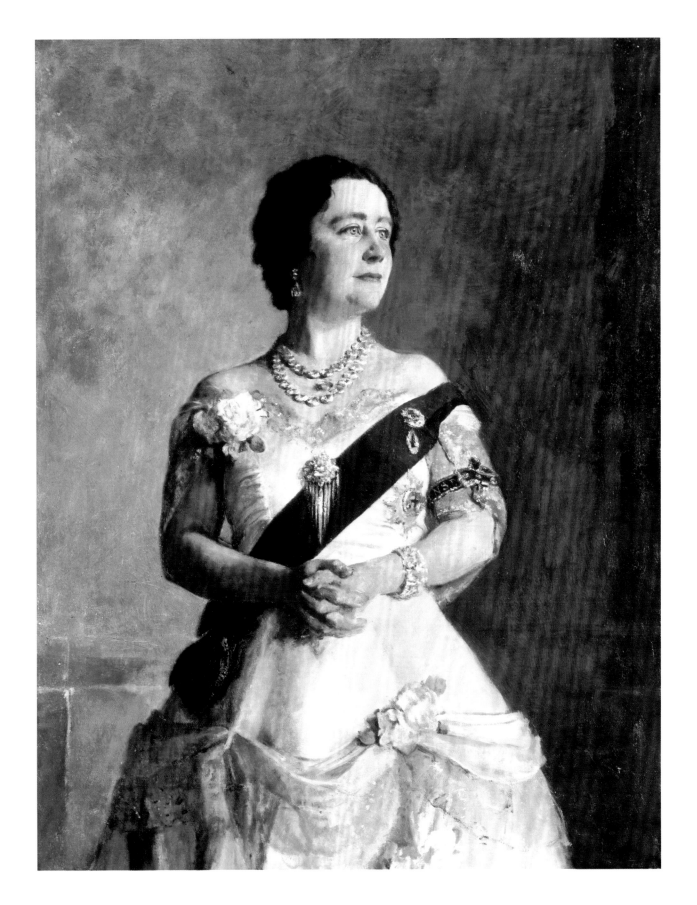

favourite Winterhalter portrait of Queen Victoria in a crinoline dress might influence the designer's choice of style for Queen Elizabeth's evening dresses. It was to be a style which from then on would be always associated with her. The exquisitely embroidered full-skirted gowns, which the Queen invariably wore for evening functions, were associated with her in the same way that her mother-in-law, Queen Mary, was renowned for her toque-style hats. Accompanying the two dolls were photographs of Queen Elizabeth in the Hartnell creations she wore for a dinner and an evening function at the White House.

France and Marianne, of course, returned to England in 1946; but what, one wonders, happened to those other royal dolls which also crossed the Atlantic in wartime to raise funds for refugee children?

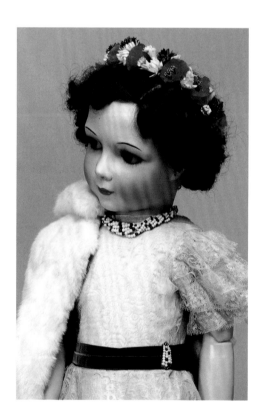

Wartime and after at Windsor Castle

Numerous though the trousseaux items and other possessions that accompanied France and Marianne to Canada were, not quite everything had been packed for their tour. As well as the large cars, prams and cots, it seems – according to the Princesses' governess – that at least two smaller items were left behind at Windsor Castle, the Princesses' wartime home. Whatever thoughts the makers had in 1938 as they prepared the contents of the dolls' trousseaux, it is unlikely that any of them would have foreseen the use to which these little pink and blue leather cases would be put two years or so later.

During the Second World War some of the rooms under the castle were used as air-raid shelters and, once the nightly raids began, they were furnished with beds and made ready for regular use.

The two young Princesses' daily routine, therefore, meant that they had to move to this austere below-stairs accommodation every evening. It seems that both of them wanted to take their own little personal treasures with them at such times and, to hold their favourite pieces of jewellery, the dolls' two jewel-boxes were 'borrowed' for the duration. Naturally, any valuable pieces had to be kept in the safe, but the Princesses' choice of brooches and necklaces which were in everyday use was carefully packed into the jewel-cases designed for France and Marianne. Once the task had been completed, every evening at 7 o'clock the Princesses would be taken down to spend the night in the comparative safety of the castle's 'dungeons'.

Although France and Marianne returned to England in 1946, it was not until 1955 that they were put on permanent public view again. In April that year a display was arranged in Windsor Castle. However, instead of being fêted as stars, with specially designed settings created for their sole use, this time they were just two items in a case of dolls that had been presented to Her Majesty over a number of years.

Fifty-six dolls from the collection, all very colourfully dressed but mainly of the fairly recent 'dolls in national costume' variety, were displayed in the case, which was fixed down the full length of a corridor used by the public on leaving Queen Mary's Dolls' House. Though France and Marianne were outstanding, easily outshining their companions in these circumstances, just sitting there with a few of their possessions they were not shown either suitably or to their best advantage.

In 1992, after consultation, it was decided to alter the whole layout of the dolls' case completely. All the other exhibits were removed, enabling France and Marianne

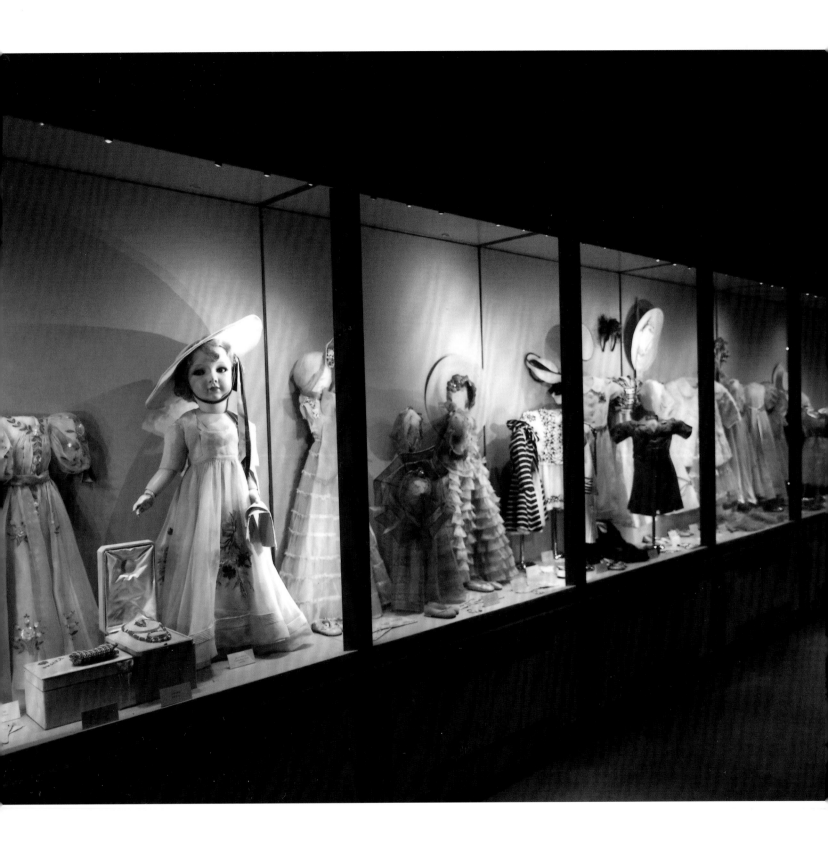

to be exhibited more fittingly, by themselves, with a larger and more representative display of their trousseaux and possessions.

The case itself was redesigned. The new façade incorporated veneered panels of ebonised mahogany on the framework. Pale-blue Tulipan was used for the lining of the interior. The lighting was also changed to fibre-optics, for conservation as well as aesthetic reasons.

Owing to the shallow depth of the long case, it was not possible to fit in any of the dolls' larger possessions – the cots, perambulators and cars, for instance, and the big leather-covered padded boxes such as the one made for the Sèvres porcelain tea-service. Not all the items in their trousseaux could be shown either; however, enough could be chosen to illustrate the extensive range of garments made to dress the dolls for every occasion, from early morning to late at night.

Suitable accessories were included to complement all the outfits; handbags and umbrellas with streetwear, parasols with garden-party gowns, fans and jewellery with evening dresses and, of course, appropriate hats, gloves, shoes, furs and even handkerchiefs with everything.

Some of the smaller possessions – dressing-table sets, writing-cases and sewing-boxes, and even a few, flat white leather boxes of table-linen – were fitted into the display as well.

At either end of the long case the dolls' blue cabin-trunks were placed open to show, in France's, fur coats and hats and, in Marianne's, lingerie and nightclothes. Near the trunks stand the two dolls, France and Marianne.

The central sections of the case contain a selection of the dolls' outfits and accessories; starting with lingerie, furs, streetwear and garden-party ensembles, then evening dresses, more lingerie, nightdresses and negligées.

As their presentation box is too large to be shown, two Sèvres cups and saucers from the set are placed near the dolls – one as if for France's morning chocolate and the other for Marianne's bedtime tisane.

Although the case cannot contain any really large items, in 2001 a bracket was fixed to the wall at the far end of the corridor to hold France's blue Citroën car. This car had been on show at Sandringham, but this was the first time for over sixty years that it formed part of the display of the dolls and their possessions.

Before it was fixed in place the car was photographed in a courtyard of the castle. To mark its return, France and Marianne left their case, put on more suitable attire for motoring, two chic daytime outfits, and – with the support of a uniformed castle attendant – posed beside one of their special custom-made Citroëns.

OPPOSITE: In 1992 the case at Windsor Castle, which had previously held an assortment of doll gifts to The Queen, was altered for the sole use of France and Marianne and items from their trousseaux. A new façade was designed and fibre-optics replaced the old lighting within the case, which stretches the length of the castle's corridor.

Needless to say, before any of the items that comprised the display could be arranged in the redesigned case, everything had to be carefully scrutinised and its condition noted. All the exhibits had been made in 1938 and, after sixty years, obviously certain garments would need some measure of conservation. Those most affected were the silver lamé fabrics and the extremely delicate, highly appliquéd or embroidered chiffons; but the superb quality of all the materials used, and the exquisite skill of those who made the trousseaux, meant that most of the items had survived the passage of time surprisingly well, and only the raincoats – which had perished in places – and one or two very fragile garments were regarded as unsuitable for exhibition even after conservation.

Though their bisque heads were undamaged, the dolls themselves needed careful attention to restore them to exhibition standard. Even the strong, elasticated cording used to join and hold together all the sections of head, body and limbs of such big, heavy dolls perishes in time. The original cording used to 'string' France and Marianne was no longer capable of holding the dolls in a standing position, and this lack of tension also meant that none of the metal linking hooks, normally attaching the limbs and head to the body, could maintain its proper position.

Both dolls had to be re-strung, and minor wear-and-tear damage to joints and some limbs meant a degree of restoration was necessary to ensure the dolls were returned to a safe and proper condition.

It was not possible to fit the dolls' larger possessions into their case but, in 2001, France's blue Citroën sports car was fixed to a wall-bracket beside the case. Before it went on display it was photographed with Marianne in the castle courtyard.

Their real-hair wigs were cleaned and then curled in their original styles to complete the dolls' conservation.

France and Marianne were then dressed in the two ensembles which were felt to be the most appropriate for the display in Windsor Castle. To commemorate the *entente cordiale*, France represents her native land in her most photographed ensemble the long organza dress embroidered with the wild flowers traditionally associated with gifts in the French countryside, red poppies, white daisies and blue cornflowers – and wears similarly decorated long gloves and a picture-hat tied with long red and blue ribbons.

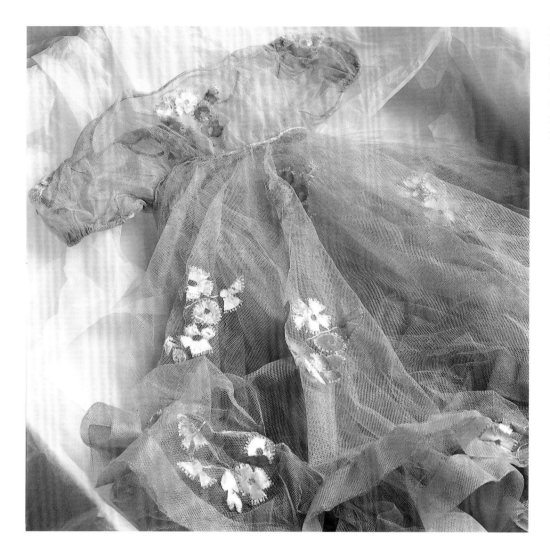

Inspection and conservation are essential to maintain any collection in good condition. However, certain fabrics are more vulnerable than others and, after sixty years, this fragile tulle dress and rubberised mackintosh now require restoration.

OPPOSITE: Marianne's ensemble
for the display at Windsor Castle
emphasises her status as a royal
doll. Appropriately, the colour
scheme also echoes her French
origin as the flags of both nations
are red, white and blue.

Red, white and blue conveniently being the colours of both countries' national flags, Marianne's outfit echoes this scheme, and she symbolises the dolls' royal status in England. In her exquisite blue-velvet-sashed white lace dress and long ermine cloak – with blue and white jewellery, beaded evening bag and a coronet of red, white and blue flowers in her dark hair – she looks most suitably attired for her regal role.

As all collectors and curators know, conservation is second only to acquisition in importance. All items in any collection need inspecting from time to time in order to spot any deterioration; and objects made of particularly vulnerable materials such as fabric or wood need a really careful scrutiny to prevent damage from pests such as moths or woodworm. There are, unfortunately, other hazards – such as extremes or alterations of temperature, lighting that is too strong or produces heat within a case, and unsuitably placed display units, perhaps near heating pipes or facing sunlit windows.

France and Marianne, with their trousseaux, are fortunate in that their case, in a windowless corridor, was custom made and lined with fire-retardant material in 1992. Its fibre-optic lighting conforms to museum requirements and regular inspections are carried out to check on humidity.

Needless to say, the clothes and other items on display are also examined and, should any exhibit be felt to be in need of respite from constantly being on view, it is taken into conservation or store and a similar one from the reserve collection is arranged in its place.

Early in 2002 everything in the case was removed in order that photographs might be taken to illustrate this book. It was, of course, an ideal time to make any alterations or adjustments necessary to maintain the condition of the dolls and their trousseaux. Both dolls also needed to have their hair attended to and reset before they could be re-dressed and returned to their case after the photographic sessions.

After examining France and Marianne, it was felt that, having been on constant display for ten years, both dolls would benefit from being re-strung to ensure that the correct tension of their connecting elastic cording was maintained. To save bringing them up to London again, this time the 'operation' was performed in a room in the castle. Afterwards, an expert stand-maker was asked to measure both dolls for new, custom-made stands, and it was discovered that the bodies and feet of the two dolls were not exactly identical. The difference was only the merest fraction, but it did explain why not all the clothes and shoes fitted both dolls equally well. New stands were specially constructed to support, as well as hold, the dolls in a standing position and thus reduce any avoidable strain.

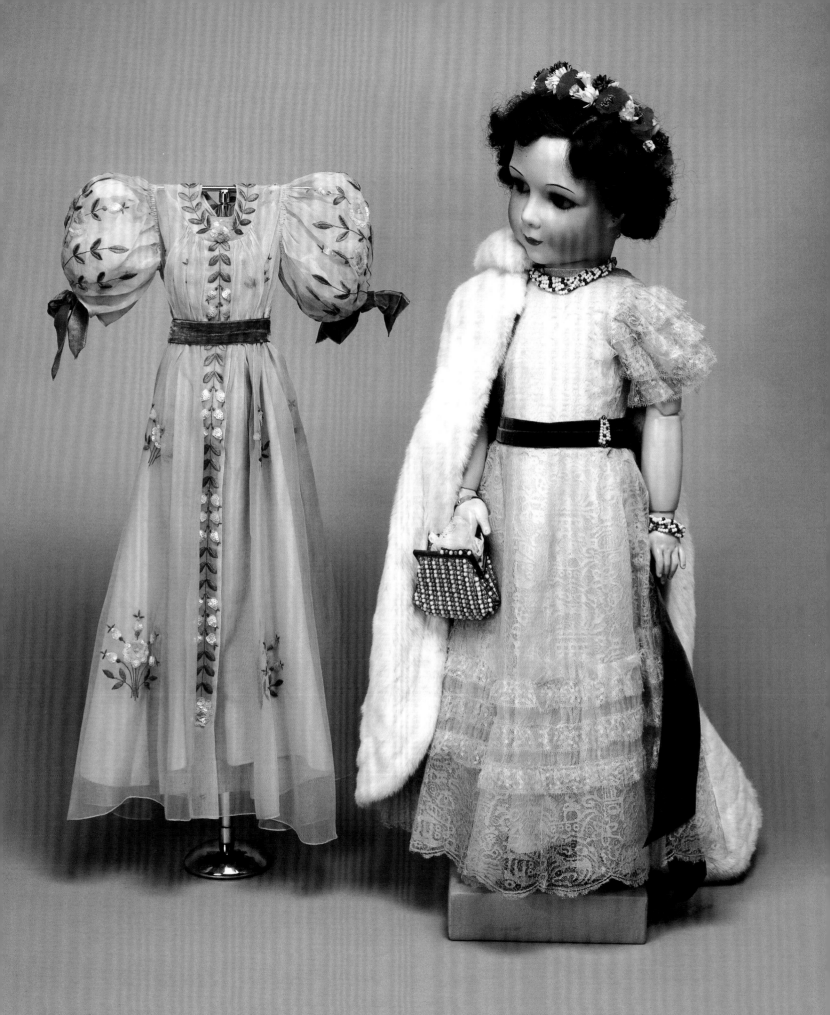

To maintain the dolls in good condition it was necessary, in 2002, to renew the elastic cording which secures the limbs, torso and head; correct tension is vital for the dolls to hold any position. Measurements were also taken then for new stands to be custom made.

Looking at France and Marianne, with their enviably unaltered beauty, it is easy to forget their age – but conservators, like doctors, always need to be aware of the passing years' effect upon their patients. When Miss Beaith escorted France and Marianne on their thirteen-month long Canadian tour, she had to dress and re-dress them many times. Sixty years ago, although it must still have been quite an undertaking, the trousseaux garments were comparatively new and therefore in almost pristine condition. In 2002 fastening the dolls' delicate and decidedly fragile dresses needed careful handling.

The lingerie has survived amazingly well, but the fine organdie, lace and embroidered nets of the garden-party and evening dresses can present a real problem when easing the dolls' arms into armholes; it is essential not to put avoidable strain on any weak section of the material.

As all the clothes had been taken off their stands, it was possible, whilst photographs were being taken, to renew the padding of each of these fixtures before the various coats, dresses and lingerie were replaced.

The dolls' accessories, too, received close attention and some minor repairs were carried out as part of the routine conservation. However, when it came to re-stringing the coral necklace supplied by Cartier, it was decided to approach the London office of the world-famous jewellers to ask for their advice. Fortunately, research in the Cartier archives in Paris produced the original drawings for the commission, so with these as a guide their London workshop was able to restore the necklace to its original design after a successful search for a matching piece of coral.

Being too big to display in the dolls' case at Windsor, the cots and perambulators at present have to be kept in store; however, they too needed some attention before being photographed at Frogmore. This beautiful old house, situated across the Home Park from the castle, provided a suitable royal setting for the photography of the two dolls.

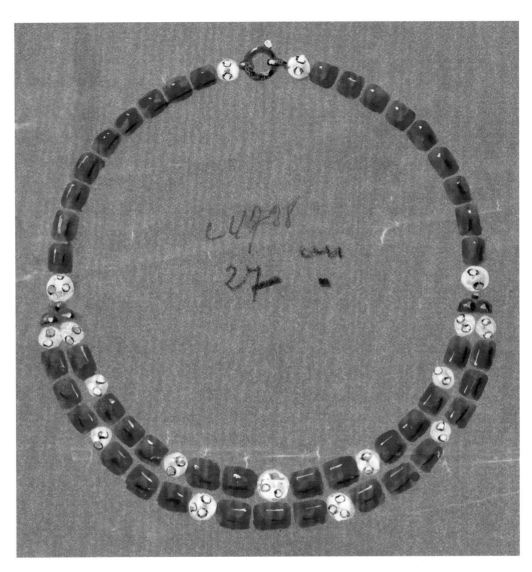

The red and white coral necklace from the set made by Cartier needed a slight repair. This was carried out at Cartier's London establishment after the designer's original drawing had been sent over from Paris for reference. It took some time to locate a piece of red coral that was dark enough to match the original necklace.

Focus

**All dolled up: Focus introduces 'It-dolls'
France and Marianne**

France wears a white organdie garden party dress and hat embroidered by Jean Patou, with gloves to match; Marianne is in a cream lace evening dress and ermine coat with jewellery by Cartier and bead handbag by Henry a la Pensee

© HM The Queen

They're young, beautiful and impeccably groomed. And at roughly 32 inches high with a wardrobe tailor-made by Paris couturiers, France and Marianne are the It-dolls of their day.

Presented by the children of France to the young Princesses Elizabeth and Margaret Rose in 1938. France and Marianne are two

Television sets were novelties when France and Marianne were made, but in 2001 the dolls featured on the Royal Insight website to celebrate their sixth decade in England.

OPPOSITE: Duvelleroy's fans were the perfect complement to the couturier's hand-made gowns.

During the time that France and Marianne have been on display at Windsor, they have attracted the attention of students of fashion, here and abroad, who have found this unique collection of Paris fashions for 1938 invaluable when researching French haute couture of the period. The opportunity to study a comprehensive ensemble of actual 1938 garments, superb *à la mode* outfits from premier couturiers and also lingerie and every kind of accessory is rare indeed. The fact that they are all miniature examples is particularly helpful as it enables viewers to see the whole fashion parade literally at a glance, before a more detailed study is made.

Although France and Marianne exemplify the finest workmanship of the 1930s, sometimes modern inventions may be used to their advantage. In April 2001 the dolls (and Queen Mary's Dolls' House) featured in that month's Royal Insight on the worldwide web. The text, mentioning their French origin and drawing attention

to the superb quality of their trousseaux, was illustrated with five photographs of the dolls and some of their possessions; it also gave details of Windsor Castle's opening times for the benefit of those who might be able to visit after learning about the dolls on the web. The fascination of fashion is timeless, especially when it is combined with the attraction of the diminutive.

'The mode in miniature' was the phrase used by one reporter to describe the dolls' trousseaux in 1938. But France and Marianne and their unique possessions are still far more than an amazing record of fashion from an almost forgotten age of elegance. To complete this unknown writer's quotation, we should see it in context; the relevant paragraphs are as follows:

> *King and President have met; all the ceremony of France and England has been marshalled to honour royal guests; guns have fired salutes, crowds roared applause, France and England have proved their* entente cordiale *by exchanging the ancient courtesies of host and guest.*
>
> *But trust the French to supplement all this pomp with an intimate, charming gesture . . . something light-hearted, yet with a serious undertone . . . a gift of dolls for our Princesses, with a 300-piece wardrobe from the great names of Paris couture.*
>
> *As a result . . . a gift that is the mode in miniature: a fashion document for future generations; a plaything for Princesses; a pawn in the move for peace.*

These words were written in 1938, but they may be echoed today as a well-merited and appropriate tribute to two extraordinary dolls, France and Marianne.

OPPOSITE: The Princesses' Christmas card for 1938 shows clearly the importance attached to the *entente cordiale* at that critical time.

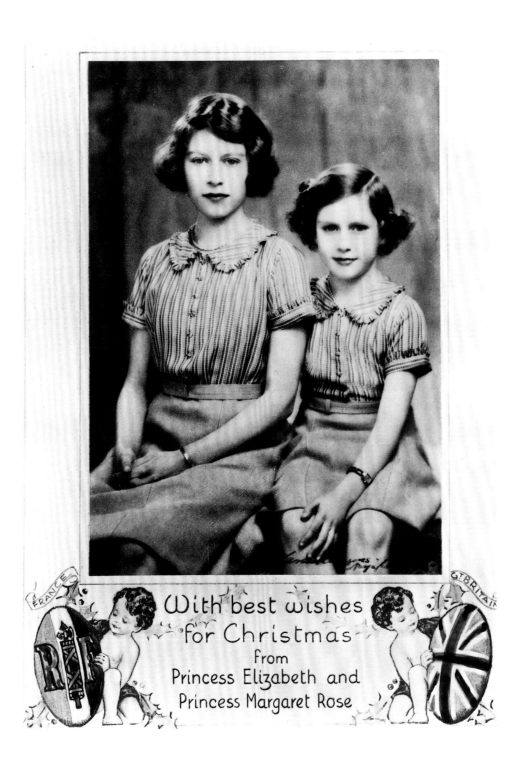

With best wishes
for Christmas
from
Princess Elizabeth and
Princess Margaret Rose

APPENDIX

CATALOGUE

OF THE EXHIBITION HELD

AT ST JAMES'S PALACE

FROM 9 DECEMBER 1938

TO 14 JANUARY 1939

THE PRINCESS ELIZABETH OF YORK
HOSPITAL FOR CHILDREN
(formerly East London Hospital for Children)

About seventy years ago Dr Nathaniel Heckford, moved by the plight of the sick children along the riverside, started a children's hospital with ten beds in an old warehouse in the Ratcliffe Highway. At first he and his wife supported it with their own money, but the demand for it would have soon overwhelmed their slender means had not Charles Dickens appealed to the public for aid. With the money he collected the present site in Shadwell was bought, but before the building could be started Heckford, worn out with overwork, died.

But his foundation flourished. The 10 beds became 135. A magnificent legacy provided a convalescence home at Bognor with 30 or more. Distinguished doctors spoke affectionately of their connection with 'Shadwell' and the experience it offered drew young medical men from all parts of the Empire and the United States of America to serve on its staff. Thus the hospital became an institution of national importance, and in 1932 the name was changed to the Princess Elizabeth of York Hospital for Children.

In 1935 reconstruction became imperative and the Board decided that the proper way to develop the work was to maintain an Out-Patient Department and a few emergency beds in Shadwell, and to build a new Hospital and Convalescent Home with accommodation for 300 children in the country. A site was provided by the gift of Banstead Wood, an estate of a hundred acres adjoining the Green Belt and completely secluded from the outside world.

In July, 1936, Her Majesty the Queen (then Duchess of York) laid the foundation stone of the new hospital. £100,000 has been collected. The first half of the Hospital and Nurses' Home is nearly completed, but the money is almost exhausted, and unless substantial sums are collected quickly (another £100,000 is needed) work will cease for lack of funds.

A new reason confirms the wisdom of this decision, for had the Country Hospital been available during the crisis, the evacuation plans would have been solved and over 300 patients could have been accommodated in the wooded security of Banstead and a refuge could have been offered to hundreds of healthy children.

Contributions will be gratefully acknowledged by the Secretary, The Princess Elizabeth of York Hospital for Children, Shadwell, London, E1.

EXHIBITS

1	Wardrobe-trunk	Innovation
2	Green sports car	Citroën
3	Blue sports car	Citroën
4	Wardrobe-trunk	Innovation
5	Flower shop	Lachaume
6	Perambulator	Le Nouveau Né
7	'France' doll	Bébé Jumeau
	Pale-pink silk organza party dress, embroidered with silk and sequins	Model by Bruyère
	Hair dressed by	Valentin
8	Cot	Le Nouveau Né
	Blankets	Mussis
9	Glass case containing	
	2 bottles of scent emblazoned with the Royal Arms	Lancôme
	8 bottles of scent	Worth
	2 bottles of scent	Guerlain
	2 bottles of scent	Bourjois
	2 bottles of scent	Coty
	2 bottles of scent	Weil
	2 bottles of scent	Lancôme
	4 fans	Duvelleroy
	2 writing-cases	Maquet
	2 cases containing thimbles and scissors	Keller
	2 bead bags	Henri à la Pensée
	2 leather bags	Pierre Masson
	2 leather bags	Hermès
	2 sets of bead jewellery	Cartier
10	Cot	Le Nouveau Né
	Blankets	Mussis

11	'Marianne' doll	Bébé Jumeau
	Ivory silk organdie evening gown,	Model by Lucile
	embroidered in gold straw	Paray
12	Perambulator	Le Nouveau Né
13	Blue organdie evening dress	Model by Worth
14	Black and white coat and skirt	Model by Worth
15	Linen sports dress and coatee	Model by Worth
16	Plaid blouse	Model by Worth
17	Plaid blouse	Model by Worth
18	Leather dressing-case	Vuitton
19	Box of handkerchiefs	Aux Mille et Une Nuits
20	Lawn and net summer morning dress	Model by Aux Mille et Une Nuits
21	Sleeveless multi-coloured dress	Model by Marcel Rochas
22	Evening gown of printed voile, in bright green, violet and yellow	Model by Marcel Rochas
23	Head-dress	Maria Guy
24	Morning dress and coatee in white	Model by Billioque Decre
25	Two bathing-suits, hand knitted	Models by Henri à la Pensée
26	Silk mackintosh in white and navy	Leda
27	Hat to match	Leda
28	White satin nightdress with hand-embroidered fichu	Model by L. Rouff
29	Lingerie	L. Rouff
30	Pale-turquoise silk chiffon evening gown and bolero embroidered in gold thread	Model by Bruyère
31	Box of handkerchiefs with embroidered monogram	L. Rouff
32	Blue sunshade	Henri à la Pensée
33	White satin dress	Model by Suzanne Joly
34	Pink and blue dressing-gown and lingerie	Suzanne Joly
35	Satin matinée coat	Model by Chalom

36	Garden-party gown and hat of pale-hyacinth-blue silk organza and lace embroidered with silver flowers	Jeanne Lanvin
37	Pink sunshade	Henri à la Pensée
38	Tea-set	Sèvres
39	White mousseline de soie Ascot gown embroidered with gold thread	Model by Maggy Rouff
40	Hat to match	Le Monnier
41	Evening gown of cyclamen silk net with appliqués of panne velvet and underdress of silver lamé	Model by Madeleine Vionnet
42	Lingerie	Madeleine Vionnet
43	White velvet chez-coat with gold girdle	Model by Suzanne Joly
44	Evening gown of silk chiffon, of three tones, pink, blue and white, with spotted-chiffon bows and ribbons	Model by Lucien Lelong
45	Box of lace handkerchiefs	Dognin
46	White organdie garden-party dress and	Jean Patou
47	Hat embroidered with cornflowers, poppies and wheat	
48	Pale-blue silk chiffon embroidered afternoon dress, coatee, hat and lingerie	Billioque Decre
49	Ascot gown of pink silk organdie, the frills edged with silver	Model by Jeanne Lanvin
50	Hat to match	Jeanne Lanvin
51	Garden-party sunshade	Vedrenne
52	Box of handkerchiefs with embroidered monogram	L. Rouff
53	White cotton morning dress, with navy embroidery and coatee to match	Lucile Paray
54	Valenciennes lace dress	Model by Chalom
55	Summer ermine swagger coat	Model by Paquin
56	White ermine evening coat	Model by Weil
57	Baby leopard swagger coat and muff	Model by Max
58	White ermine evening cloak	Model by Max
59	Grey Indian lamb coat and muff with collar and cuffs of red velvet	Model by Jungmann
60	Underwear	Charmis

61	Pink lingerie	Aux Mille et Une Nuits
62	Pink lingerie	Aux Mille et Une Nuits
63	Brown satin morning dress, with trimmed gathers	Model by Paquin
64	Satin matinée coat	Model by Chalom
65	White ermine evening coat	Model by Weil
66	Beach suit – white trousers, blue reefer coat and white cap with black peak	Jean Patou
67	Dressing-table set	M. Garand
68	Negligée in blue satin	Charmis
69	Red and green sports outfit	Marcel Rochas
70	Blue velvet chez-coat with silver girdle	Model by Suzanne Joly
71	White ribbed silk dress, with navy and white silk coat	Lucile Paray
72	Negligée in pink satin	Charmis
73	Green satin chez-coat	Charmis
74	Valenciennes lace dress	Model by Chalom
75	Evening gown of flesh-pink mousseleine de soie, embroidered in pink and silver	Model by Maggy Rouff
76	Silver silk net evening gown, with appliqués of silver panne velvet and underdress of silver lamé	Model by Madeleine Vionnet
77	Lingerie	Madeleine Vionnet
78	White shadow lace afternoon dress, with blue velvet sash and ornamental star buttons	Model by Lucile Paray
79	Box of lace handkerchiefs	Dognin
80	Pink silk chiffon garden-party dress, with shoulder trimmings of forget-me-nots	Model by Lucien Lelong
81	Pink organdie bonnet trimmed with forget-me-nots	Suzy
82	Blue silk dressing-gown and lingerie	Suzanne Joly
83	Lawn and net summer morning dress	Aux Mille et Une Nuits
84	Nightdress in pink satin, with chiffon bedjacket	Charmis
85	Blue silk dress	Suzanne Joly
86	Blue woollen school dress	Robert Piguet
87	Beaver coat	Paquin

88	Beaver hat, studded with multi-coloured stones	Agnès
89	Green tweed coat and printed silk dress	Marcel Rochas
90	White satin nightdress with hand-tucked and gauged yoke	L. Rouff
91	Navy and red silk mackintosh	Leda
92	Hat to match	Leda
93	Box of gloves	Alexandrine
94	Ocelot fur coat trimmed with green cloth	Model by Jungmann
95	Hat to match	Jane Blanchot
96	Hand-embroidered afternoon tea-cloth with six serviettes	L. Rouff
97	Leather dressing-case	Vuitton
98	Café au lait satin morning dress with trimmed pleats	Paquin
99	Hand-embroidered afternoon teacloth with six serviettes	L. Rouff
100	Coloured scarves	Henri à la Pensée
101	Garden-party sunshade	Vedrenne
102	Dressing-table set	M. Garand
103	Hat	Billioque Decre
104	White organdie dress	Worth
105	Leather belt	Henri à la Pensée
106	Box of gloves	Alexandrine
107	Leather belt	Henri à la Pensée
108	Box of handkerchiefs	Aux Mille et Une Nuits
109	Dress-trunk containing wool tricot sports jacket, dressing-gown and silk lingerie	Valisère
110	Dress-trunk containing wool tricot sports jacket, dressing-gown and silk lingerie	Valisère
111	Dark-blue silk dress	Robert Piguet
112	Sports umbrella	Vedrenne
113	Umbrella	Vedrenne
114	Umbrella in oiled silk	Henri à la Pensée
115	Umbrella in oiled silk	Henri à la Pensée
116	Yellow silk umbrella	Henri à la Pensée
117	Green silk umbrella	Henri à la Pensée
118	White lingerie	Grande Maison de Blanc

FURTHER READING

ROYALTY

R. Allison and S. Riddell (eds.), *The Royal Encyclopedia*, London, 1991

L. Doeser and K. Sullivan, *H.M. Queen Elizabeth The Queen Mother. The Celebration of a Life, 1900–2002*, Bath, 2002

M. Laing, *The Queen Mother. The Life that Spanned a Century 1900–2002*, ed. J. Bishop, London, 2002

J. Roberts (ed.), *Royal Treasures. A Golden Jubilee Celebration*, London, 2002

DOLLS

M. von Boehn, *Dolls and Puppets*, London, 1931

O. Bristol, *Dolls. A Collector's Guide*, London, 1997

D., J. and E. Coleman, *The Collector's Book of Dolls' Clothes. Costumes in Miniature 1700–1929*, London, 1976

D., J. and E. Coleman, *The Collector's Encyclopedia of Dolls*, London, 1970

F. Eaton, *Care and Repair of Antique and Modern Dolls*, London, 1985

C. Goodfellow, *The Ultimate Doll Book*, London, 1993

S. Kevill-Davies, *Yesterday's Children. Antiques and the History of Childcare*, Woodbridge, 1991

C.E. King, *A Collector's History of Dolls*, London, 1977

M. Tarnowska, *Fashion Dolls*, London, 1986

M. Whitton, *The Jumeau Doll*, New York, 1980

FASHION

C. Beaton, *The Glass of Fashion*, London, 1954, facsimile 1989

J. Dorner, *Fashion in the Twenties and Thirties*, Shepperton, 1973

C. Hall, *The Thirties in Vogue*, London, 1985

N. Hartnell, *Silver and Gold*, London, 1955

G. Howell, *Vogue. Sixty Years of Celebrities and Fashion from British Vogue*, London, 1978

A. Latour, *Kings of Fashion*, London, 1958

A. Lurie, *The Language of Clothes*, London, 1982

A. Ribeiro and V. Cumming, *The Visual History of Costume*, London, 1989

J. Robinson, *The Golden Age of Style, Art Deco Fashion Illustration*, London, 1976

D. Sirop, *Paquin*, Paris, 1989

DOLL WEBSITES

www.collectdolls.about.com

www.our-world-of-dolls.com

www.virtualdolls.com

AUTHOR'S ACKNOWLEDGEMENTS

Many people have contributed to the contents and appearance of this book and I should like to express my thanks for all the help I have received.

At the Royal Collection I owe a great debt of gratitude to Gay Hamilton for her help over many years and for her supervision of the photography and the conservation of the dolls at Frogmore House. My thanks also go to Henrietta Edwards for her help with the research and to a large number of her colleagues in London and at Windsor, including Anthony Barrett, Sir Geoffrey and Lady de Bellaigue, Pamela Clark, Frances Dimond, Melanie Edwards, Gemma Entwistle, Helen Gray, Jill Kelsey, Roderick Lane, Karen Lawson, Jonathan Marsden, Elaine Pammenter, Lucy Scherer, Prudence Sutcliffe, David Westwood, Matthew Winterbottom and Eva Zielinska-Millar.

I particularly appreciated the support and all the work of Marie Leahy, the book's editor. My thanks, too, to the designer and art director Mick Keates, who was involved with the book from the earliest stages, and to the editorial and production staff at Book Production Consultants in Cambridge.

I am deeply grateful to Nicholas Pertwee for his translation work and for his determined research into the dolls' Canadian tour; both were invaluable. Special thanks are also due to Olivia Bristol and Caroline Goodfellow for all their kindness and help; to Di Powell, Margaret Towner and Jennie Bowen for their assistance; to Matthew Ward for his photography and for his kind co-operation; to Jonathan Evans, Archivist at the Royal London Hospital; to John Entwistle at Reuters; to Daniel Agnew at Christie's; to Nicholas R. Mays at News International; to motoring historian John Reynolds; and to Rowena House and Ruth Mackman of the WRVS.

In France, my warmest thanks go to Barbara Spadaccini-Day at the Musée des Arts Décoratifs, Paris, for her support and for vital supplies of source information. I also appreciate deeply the generosity of Madame Bugat-Pujol, who permitted me to study photographs from her personal archives; I much appreciated, too, the kindness of Samy and Guido Odin, at the Musée de la Poupée, Paris, for their help with photographs.

I am truly grateful to Ann Coleman for so kindly searching for and supplying information from the Coleman Archives. I also wish to thank the library staff at the Margaret Woodberry Strong Museum, Rochester NY, for their help.

In Canada, particular thanks are due to Heather Falconer for her careful research in various Canadian archives. I am also grateful to Jim Comrie and to everyone who provided pieces of information in response to all the e-mail enquiries from England.

Index

PICTURE CREDITS

The publishers are grateful to all institutions and individuals who have lent material for this book. Every effort has been made to contact copyright holders; any omissions are inadvertent and will be corrected in future editions if notification of the amended credit is sent to the publishers in writing. (Reference below is to page numbers.)

Reproduction of all items in the Royal Collection is © HM Queen Elizabeth II. Photographer Eva Zielinska-Millar: front of jacket, frontispiece, iv (top), 29, 30, 32, 35, 36, 38, 40, 47, 57, 58, 60, 61, 62, 66, 67, 70, 71, 72, 73, 74, 76, 79, 80, 88, 103, 119, 133.
Photographer Matthew Ward: half title, title page, v (top), 3, 4, 10, 11, 31, 33, 34, 39, 65, 68, 69, 75, 77, 81, 82, 83, 84, 108, 113, 115.
Photographer John Freeman: 8.

Archive: 6, 12 (photographs by Marcus Adams, Camera Press, London), 17, 21, 23 (photographer *Daily Sketch*), 48 (Pathé Gazette), 49, 52 (top), 78, 110, 116, 118, 121 (photograph by Marcus Adams, Camera Press, London).
18 © Reserved/The Royal Collection (photograph attributed to Hay Wrightson);

98 © Reserved/The Royal Collection.

British Library Newspaper Library 20, 45
(*Harper's Bazaar*), 46
Cartier/Cartier Paris Archives 117
Centre Documentation Jouets, Musée des Arts Décoratifs, Paris 24, 28, 41, 43, 87
Faith Eaton Collection 26, 42, 52 (bottom), 95 (bottom), 96
The Illustrated London News Picture Library iv (bottom), v (bottom), 22, 44, 50, 51, 56
Musée de la Poupée, Paris (Collection Odin), photographer Guido Odin 86
Montreal Gazette 101
National Archives of Canada (copy

negative number C52280) 94
National Portrait Gallery, London, copyright reserved 107
National Trust Photographic Library (John Hammond) 15
PA News Photo Library 112
Royal London Hospital Archives and Museum 54, 55
St Thomas Times Journal, St Thomas ON (25.4.1941) 95 (top)
Whitman Publishing Company 90, 91, 92

Map of the Canadian Tour (page 104) prepared by Stefan Chabluk.

VISITING WINDSOR CASTLE

INFORMATION FOR VISITORS

FRANCE AND MARIANNE now form part of the Royal Collection and they
can be seen at Windsor Castle in Berkshire. A selection of some of the most
beautiful items from their trousseaux is also on permanent display on the visitor route.

Opposite the dolls' showcase is another masterpiece of miniature design,
QUEEN MARY'S DOLLS' HOUSE. This imposing London townhouse was intended
to demonstrate the skills of British artists and craftsmen and to provide a record
of the lifestyle of British monarchy in the twentieth century. It was designed by
Sir Edwin Lutyens and was presented to Queen Mary, the consort of King George V,
in 1924. Like France and Marianne, this royal gift offers the visitor a glimpse
of a past age of elegance; its spacious rooms contain scaled-down versions of
every possible luxury and modern amenity.

Windsor Castle is open to visitors throughout the year but, as it is a working
royal palace, opening arrangements may sometimes be altered at short notice.
For further information please contact:

The Ticket Sales and Information Office
Buckingham Palace
London SW1A 1AA

Tel: 020 7 321 2233 Groups: 020 7 799 2331
Fax: 020 7 930 9625
E-mail: information@royalcollection.org.uk
groupbookings@royalcollection.org.uk

You can also visit the Royal Collection website at http://www.royal.gov.uk

Published by
Royal Collection Enterprises Ltd
St James's Palace
London SW1A 1JR

For a complete catalogue of current publications, please write to the address above,
or visit our website at http://www.royal.gov.uk

ISBN 1 902163 57 5

British Library Cataloguing in Publication Data
A catalogue record of this book is available from the British Library

Designed by Mick Keates
Produced by Book Production Consultants plc, Cambridge
Printed and bound by Graphicom srl, Vicenza, Italy